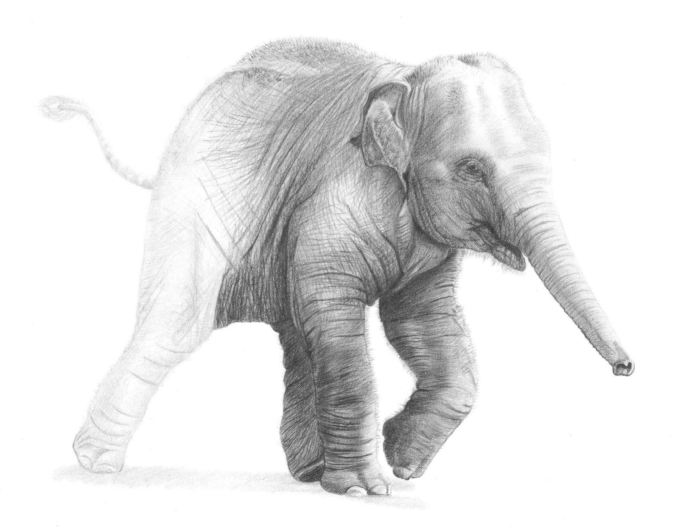

Drawing Animals
Lucy Swinburne

Dedication

To my mum and of course my
lovely daughters – thank you
for continuing to believe in me.

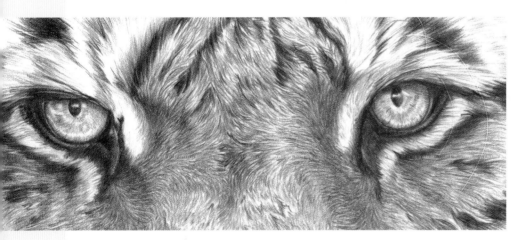

Drawing Animals

Lucy Swinburne

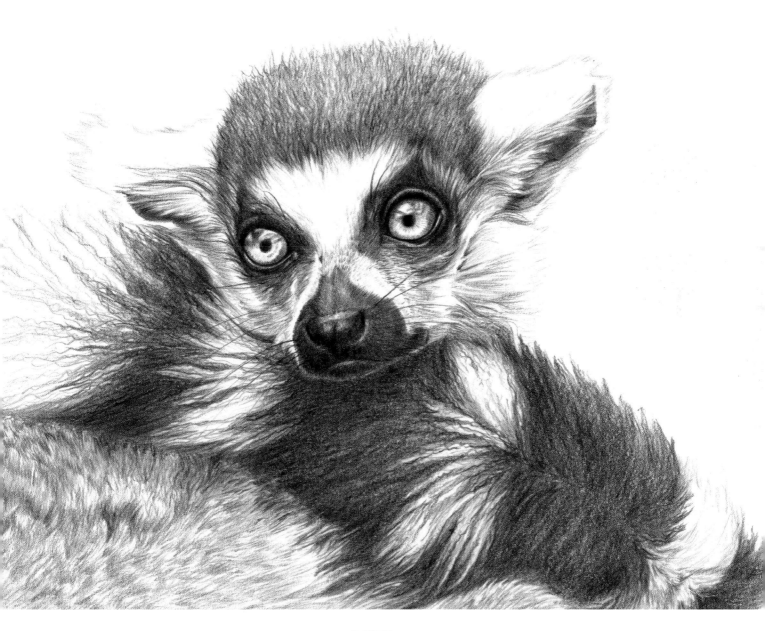

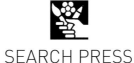

SEARCH PRESS

This edition published in 2020

Search Press Limited
Wellwood, North Farm Road,
Tunbridge Wells, Kent TN2 3DR

Original edition first published in 2013 as
Drawing Masterclass: Drawing Animals

Illustrations and text copyright
© Lucy Swinburne 2020, 2013

Photographs and design copyright
© Search Press Ltd. 2020

ISBN: 978-1-78221-719-0

The Publishers and author can accept
no responsibility for any consequences
arising from the information, advice or
instructions given in this publication.

Suppliers
If you have difficulty in obtaining any of
the materials and equipment mentioned
in this book, then please visit the Search
Press website for details of suppliers:
www.searchpress.com

Follow the author's page on Facebook:
Lucy Swinburne - Pastel Pet Portraits

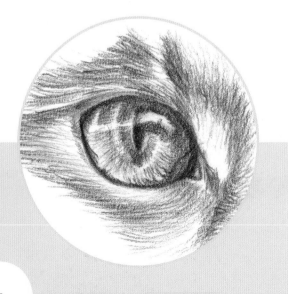

Acknowledgements

I would like to take this opportunity to say a special thank you to
my whole family for all the tremendous support they have given me
while I was writing and illustrating this book.

I need to say a huge thank you to Lynn Whitnall, Director at
Paradise Wildlife Park, and say also how grateful I am to her for
helping me get closer to her animals. This thank you extends to
all the staff at the Park for making me feel so welcome, and for all
their help in obtaining some of the wonderful wildlife photographs I
used for reference throughout the book.

Many thanks are offered as well to the following people for allowing
me to use their photographs, when my own efforts failed!

Kirikina from Paint My Photo for inspiring the Guinea Pig image on
page 28.

Wild Portrait Artist from Wildlife Reference Photos for Red Panda
image (see page 84).

Sue Wallace for the photographs used for Wolf (see page 72), Tiger
(see page 90) and Meerkat (see front cover and page 78).

Brian for the photograph used for Bearded Dragon (see page 132)
courtesy of www.beardeddragon.org.

Ruth Archer from Wildlife Reference Photos for inspiring Galloping
Foal (see page 136).

Sue Dudley from Wildlife Reference Photos for inspiring Jumping
Dog (see page 137).

Hollie Gordon from Wildlife Reference Photos for Baby Asian
Elephant image (see page 138).

Finally, a big, big thank you to anyone whose beautiful pets are
illustrated in this book.

Front cover
The Lookout
21 x 30cm (8¼ x 11¾in)
Graphite pencil on smooth white card.

Patiently Waiting
21 x 30cm (8¼ x 11¾in)
*Graphite pencil on smooth
white card.*

Page 1
Tom
21 x 30cm (8¼ x 11¾in)
*Graphite pencil on smooth
white card.*

Asian Elephant
30 x 21cm (11¾ x 8¼in)
Graphite pencil on smooth white card.

Page 2
Tiger Stare
21 x 11cm (8¼ x 4½in)
Graphite pencil on smooth white card.

Page 3
Lemur
21 x 30cm (8¼ x 11¾in)
Graphite pencil on smooth white card.

Opposite
Lone Wolf
72 x 52cm (28¼ x 20½in)
Pastel pencils on smooth grey card.

CONTENTS

INTRODUCTION

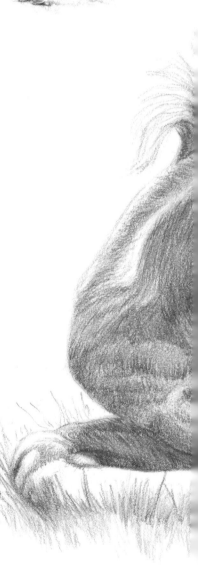

In all the years that I have been teaching there is one question that I have been asked many times: 'Can you be taught how to draw?' I am a firm believer in the old adage that you can achieve anything if you want it enough, and this goes for drawing too. If you have the passion and desire to draw then anything is possible. It certainly helps if you are born with the ability to judge perspective and note proportion, but this can be learnt over time through trial and error. When you have drawn something that pleases you, it will have been worth the time and effort.

In this book I have set out to show you how to approach your subjects with as much forethought as possible and to enable you to produce a portrait of which you can be proud. You will learn how to choose your materials, set up your work area, observe your subject, compose it and draw it – everything from start to finish. There are many considerations to make before putting pencil to paper and, although I have only scratched the surface in this book, I felt there was no need to overwhelm you this early on!

In my opinion, the most important ingredient required for completing a good drawing is the reference material. In my case that is photographic reference. As I am not a professional photographer and have had to learn on the job, all I can say is thank goodness for digital cameras! Now I can see immediately if I have taken enough decent images to work from. I have also learnt to take close-ups of features like eyes and noses, to help later on when I am drawing these details. Too often I have returned home, keen to start, and then realized my subject is missing a tail that was tucked behind, or to find that I could have benefitted from another view of my subject from a different angle. You do not need an expensive camera but if your particular speciality is animal portraits, a decent zoom lens is going to further your cause. With animal photography, patience is the keyword. Watching and waiting will not only improve your observation skills but enable you to capture that special shot.

As a complete beginner or even an amateur, the hardest part of drawing is the actual drawing. If you are not blessed with the talent to draw freehand (and not many people are, even professional artists), do not fear, you will learn all about the methods available for transferring your image to paper within this book. You will also learn how to create different textures and how to complete a drawing by following the step-by-step examples provided.

As a teacher, the most satisfying element of passing on my knowledge is seeing the enthusiasm and understanding grow in my students. The discovery that I could actually enrich other people's lives simply by sharing my own love of drawing was a fantastic realization.

It is with this thought that I will leave you to study my book at your leisure and hope that you find it informative and inspiring.

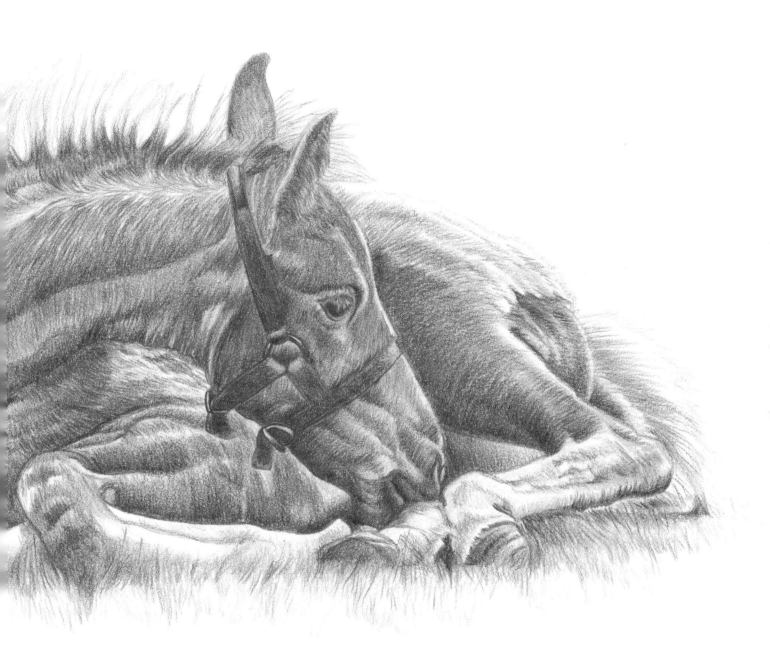

That Awkward Bit
30 x 21cm (11¾ x 8½in)
Graphite pencil on smooth white card.

This leggy young foal lives near my home. She has yet to shed her coat of baby hair, which adds to the appeal of the drawing.

THE HISTORY OF DRAWING ANIMALS

Horse, in the style of prehistoric cave paintings
28 x 21cm (11 x 8¼in)
Graphite pencil on smooth white card.

It is not known when people first began drawing animals or indeed who was the first person to make their mark. The Palaeolithic era saw the development of tools from stone, and the cave paintings of this era are undoubtedly the source of animal drawing. The oldest of these date from 33,000BC and it is likely that the animals in these cave drawings were painted as a type of ritual related to hunting. Others suggest that they were painted as part of religious ceremonies or as a form of calendar. One view is that early man painted these animals as a record of the beasts that they had killed, as no evidence would have remained once they had been consumed. The drawings became a record of each hunter's achievements. Most interestingly, it is very obvious that these drawings were public and could be viewed by anyone.

These cave paintings were always 'floating' with no ground or horizon line and lacked depth, but had a high level of detail. This showed that the artists had a very close relationship with the animals they were drawing. Many ancient examples of cave paintings have been found throughout Europe and in particular in France. The oldest known cave paintings are of big cats and rhinoceroses in the Chauvet-Pont-d'Arc Cave in the Ardèche region. The discovery of shaped stone and sharpened bones made it very likely that the artists painting these images were in fact the hunters. The pigments they used to create the colours were very primitive – burnt wood or chalk mixed with earth, for example – but they were still very effective.

Animals have appeared in the artwork of numerous cultures throughout history. The ancient Egyptians painted many of their gods with the heads of animals, and tribal art from all over the world includes images combining animal and human features. During the Middle Ages, European artists embellished their manuscripts with amazing mythical animals, and during the fourteenth century horses were commonly depicted with exaggerated masculine characteristics, including muscular thighs, stocky bodies and short tails.

Leonardo da Vinci (1452–1519AD) the Italian Renaissance genius, was one of the first artists to create studies of his animal subjects and produce preliminary drawings. There are many examples of this, whether it was horse head studies, or life studies of cats and dogs.

Albrecht Dürer (1471–1528AD), one of da Vinci's contemporaries, was the first modern artist to see animals as worthy subjects for paintings. This happened during a time when many explorers were returning from distant lands with plants and new animal species, and interest in the natural world was being sparked. Dürer used pen and ink to create very detailed studies.

Cat studies, in the style of da Vinci
30 x 42cm (11¾ x 16½in)
Graphite pencil on smooth white card.

One example, entitled *A Rhinoceros* (1515AD), was created from a sketch supplied by an unknown artist. Since Dürer never actually saw the animal first-hand, there were anatomical errors. In contrast, he also painted a watercolour and gouache painting of a young hare in 1502AD. The result was an amazingly realistic hare, especially considering it was most likely created from a stuffed animal as opposed to drawing from life.

Following renewed interest in Dürer after his death, the 'Dürer Renaissance' began in Nuremburg. An artist called Hans Hoffman (1530–1591/2AD) became well known for his portraits and studies of plants and animals based on Dürer's work. He went on to achieve a sense of realism superior to that of Dürer's own work.

As time moved on, interest in animal art continued to grow and another great painter emerged. George Stubbs (1724–1806AD) was probably the greatest equestrian painter of all time, but was never fully appreciated during his lifetime. His paintings of horses and foals were depicted in fine detail because he knew their anatomy so well. Unfortunately, equestrian and sporting life paintings were frowned upon by the critics and his work did not receive the credit it deserved until the twentieth century. His unusual technique involved first painting the horses and then adding the background at the end. Stubbs considered the background to be the least important part of a painting, and he produced one famous painting of horses with no background, *Mares and Foals without a Background*, in 1762AD. Many people consider this to be his best work. Following on from Stubbs, many Victorian artists began painting intimate portraits of their domestic pets and livestock.

In the late nineteenth to early twentieth centuries, an Expressionist artist called Franz Marc took things a stage further by painting abstract animals. One particular oil painting called *Tiger* (1912AD) showed the tiger and background completely made up of geometric shapes. The tiger stands out from the background as it is produced in strong yellow and black shapes to depict the animal's markings.

Cecil Aldin was another artist working at this time. He began his career as an illustrator for journals and magazines in 1890AD. Aldin was a keen sportsman and many of his works depicted 'the chase'. One of his most famous works was *Master of Hounds*. He also produced a book of pastel drawings which included a selection of sketches of his own dogs on his sofa.

Pablo Picasso also had an influence on the art of drawing animals. During December 1945AD, he produced eleven different developments of a lithograph, called *Bull*. He began with a drawing of a bull rendered in detail and then began to strip the picture down stage by stage; first into a mythical creature, then showing

Jack Russell, in the style of Cecil Aldin
30 x 21cm (11¾ x 8¼in)
Graphite pencil on smooth white card.

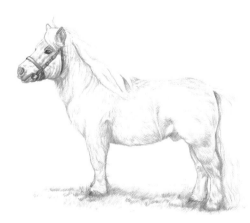

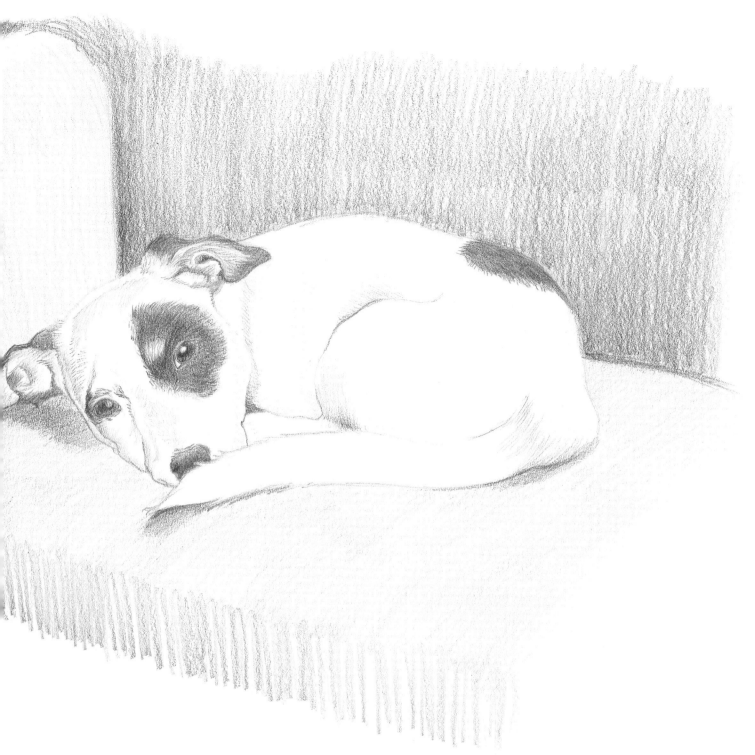

the anatomy in a defined way, right through to
simplifying the structure, creating line drawings and almost totally
recreating his first drawing. The finished picture was rendered in
Picasso's familiar style, with the bull stylized and shown in an
abstract form.

Of course, artists painted a huge range of animal genres during
the twentieth century and even created a few of their own. Wildlife
art and animal portraiture is now very collectible and has a great
following. It is of course my own favourite subject.

MATERIALS

In this chapter, I will explain the different media available to you to produce your drawings and show you the different marks each type make in order to give you an idea of how they work. Next I will tell you about the different types of surface material available and show you the effects of drawing on some of them. You should then be ready to begin to plan your picture.

GRAPHITE PENCILS

Everyone has used a graphite pencil and they are probably the first medium you would think of using to produce a drawing or sketch. There are many different types, including technical pencils (hard), sketching pencils (medium) and whole graphite sticks (soft). All of these are easily sharpened with pencil sharpeners and are easy enough to erase if a mistake is made, as long as limited pressure has been applied to the paper or card. Graphite pencils can break if dropped onto a hard surface, so take care of them when they are out of the box.

Pencils are graded. Those marked H are harder and they typically range between H and 4H. The higher the number, the harder the graphite. The softer range of pencils are marked B, and they generally range from HB to 9B. The higher the number, the softer the graphite.

Typical sketching or technical pencils are light and wooden-cased, and range from HB up to 6B. The heavier graphite sticks come in a wider range of grades, from HB to 9B. Graphite sticks wear down more quickly and are very soft and grainy.

If you want crisp, clean lines or edges to your drawings, the more typical wooden pencils would be better suited to the task.

When you first use a graphite pencil or stick, the temptation is to use one grade (a 2B, for instance), to complete a whole drawing. Certainly you can use only a single grade and alter the pressure of the pencil to create darker tones as you progress, but a much more professional approach is to use several grades, building up from light to dark. This approach requires you to begin with a light pencil, such as a 2H, to lay down the base for the different tones to follow. You then 'top up' by using a 2B or 4B pencil to darken further. These two grades of pencil may be enough on their own (depending on how dark you need to go), but there is the option of using a 6B and up for deeper shades.

Graphite pencil techniques

On this page are some simple shapes demonstrating shading and textural techniques using graphite pencils. Drawing with graphite pencils can be extremely rewarding but plenty of practice is required to help you discover your own unique style.

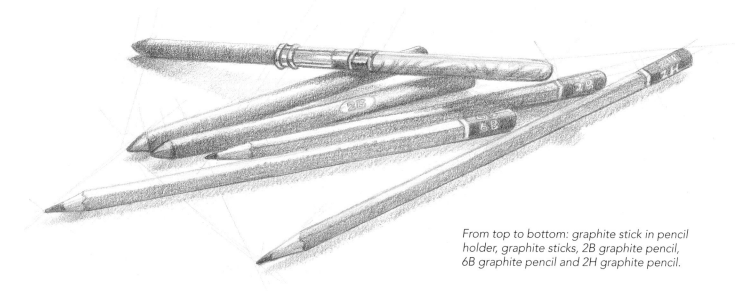

From top to bottom: graphite stick in pencil holder, graphite sticks, 2B graphite pencil, 6B graphite pencil and 2H graphite pencil.

Crosshatching
2B graphite pencil.

Graduated shading
2H, 2B and 4B graphite pencils.

Stippling
6B graphite pencil.

Graduated shading blended with tortillon
(see page 17)
2H, 2B and 4B graphite pencils.

Circular shading
2H and 2B graphite pencils.

Scribbling
6B graphite pencil.

Negative shading
2H, 2B and 4B graphite pencils.

Battery eraser used over the top of shading
work made with 2H, 2B and 4B graphite
pencils. The pencil work was blended with a
clean finger before the eraser was used.

Curved crosshatching
6B graphite pencil.

PASTEL, CARBON AND CHARCOAL PENCILS

These media produce drawings that are loose in style, with less detail than graphite pencils. This is great, especially if you want to work on a large scale. With any of these media you will need to take care as you work because they easily smudge; resting your hand on some spare, rough paper will help prevent this.

Pastel pencils

Pastel pencils are extremely versatile and different makes will offer subtle differences in blending, application and ease of sharpening. Most pastel pencils will fit in a standard pencil sharpener, but some makes are too wide to fit in a conventional sharpener. For these, a point can be maintained by using a scalpel or sandpaper block. I do not recommend battery-operated sharpeners for pastel pencils as they are too abrasive.

The main difference between pastel pencils and carbon and charcoal pencils is that it is much easier to establish finer detail with pastel pencils, especially in small areas.

Pastel pencils (from top to bottom: black, light grey, medium grey).

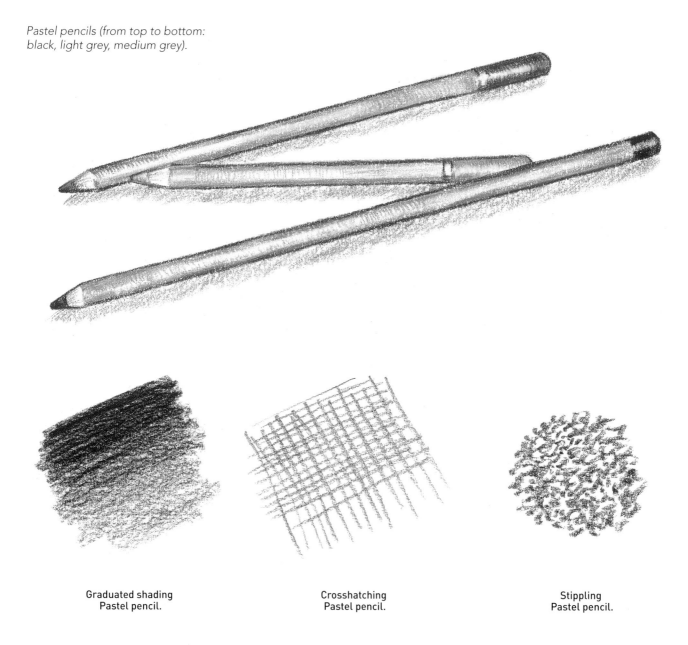

Graduated shading
Pastel pencil.

Crosshatching
Pastel pencil.

Stippling
Pastel pencil.

Carbon and charcoal pencils

If you want to produce quick sketches from life, or preliminary sketches for a main drawing, carbon or charcoal pencils/sticks are an excellent medium to do this with. They are a good medium for producing fine sketches of animals and just as great for shading in large background areas.

 If you intend to use a battery eraser with these media, be aware that the particles removed by the rubber tip will spray out and adhere themselves to other areas of the drawing – and not necessarily where you want them! Where possible, the best way to remove these unwanted particles is to gently blow them away. If they resist, you can brush them away gently with a soft make-up brush.

Carbon pencils can be fairly messy, so I recommend that you work at quite an acute angle, to allow loose particles to fall away from your drawing area.

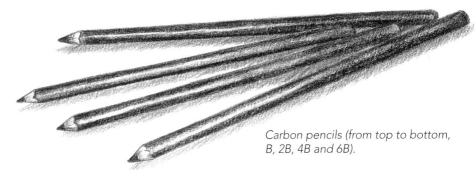

Carbon pencils (from top to bottom, B, 2B, 4B and 6B).

Graduated shading
2B carbon pencil.

Crosshatching
2B carbon pencil.

Curved crosshatching
2B carbon pencil.

Charcoal and sketching pencils (from top to bottom: 8B, 4B and HB), plus charcoal sticks.

Graduated shading
Charcoal stick.

Crosshatching
Charcoal stick.

Stippling
Charcoal stick.

PENS

Ink and ballpoint pens are traditionally used in conjunction with watercolour washes for animal drawing, the watercolour being used to fill in the background behind the ink pen drawing or sketch. When tackling architectural drawings, technical and ballpoint pens really come into their own. However, when drawing any subject matter with them, you have to be confident with your strokes.

Before you start, you need to understand that your completed image will contain all your construction lines and any errors you made along the way. This can, however, add interest and movement to the picture. Life drawings, for instance, can look quite spectacular when rendered in ballpoint pen.

Ink pens are perfect for any type of study or drawing including animals, landscapes and structures. If you intend to use any type of pen, make sure you experiment with different types of paper or card, in smooth and with differently textured surfaces.

As you are working, you must use a piece of rough paper to rest your hand on. Just like ink pens, ballpoint pens can take a short while to dry – smudges are easily created with one wrong move, but not so easily corrected!

A selection of refillable technical ink pens. Three fineline pens ranging from 0.35mm to 0.7mm, and two ballpoint pens.

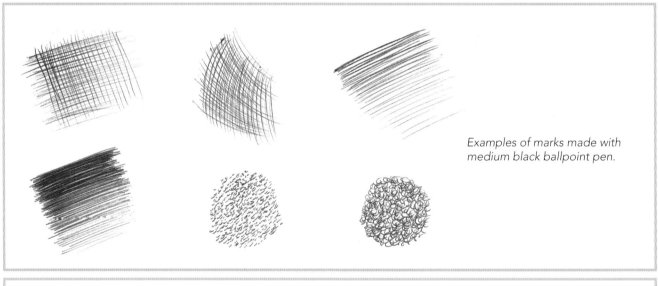

Examples of marks made with medium black ballpoint pen.

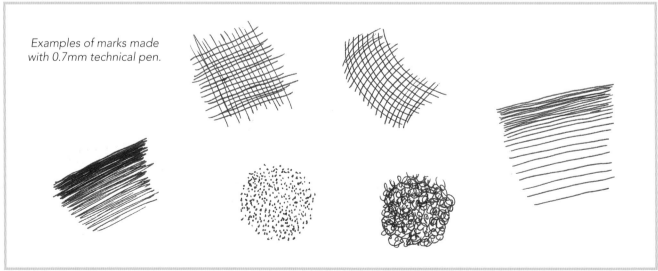

Examples of marks made with 0.7mm technical pen.

OTHER MATERIALS

There are lots of other materials you can use, some of which are compulsory and others that are not. Trial and error will tell you whether you need them.

Masking tape is a compulsory item for securing your card to your working surface (whether it is a desk or an MDF board). The best rolls I find are bought from DIY stores, so there is no need to splash out on the most expensive types in art shops.

Another compulsory item is your **putty eraser**, the best types of which are kneadable. This simply means that you can shape it to lift off small areas of pencil or roll it into a ball for larger areas. It is also self-cleaning. When it is dirty just fold the soiled outer edges in towards the centre and hey presto, a clean eraser!

Whether you use a **scalpel**, an **electric pencil sharpener** or a **manual pencil sharpener** is a matter of personal choice. Note that electric sharpeners can be too abrasive for many pastel or carbon pencils, which break easily. Whichever you choose, I suggest that you use a small pot (with a lid) to catch your sharpenings as you work, to save trips to the wastepaper basket once you have found a comfortable working position.

Tortillons, or **blending sticks**, are again something you need to try first, to see if they suit your technique. An **acetate grid** is also not something everyone will want to use, but later on in the book I describe in detail how to use the grid method for transferring images, should you wish to try. You will need a **ruler** for this too.

Finally, I recommend a **soft brush** of some kind, such as a large make-up brush, to dust off your drawing and free it of any pencil shavings or eraser finings as you work.

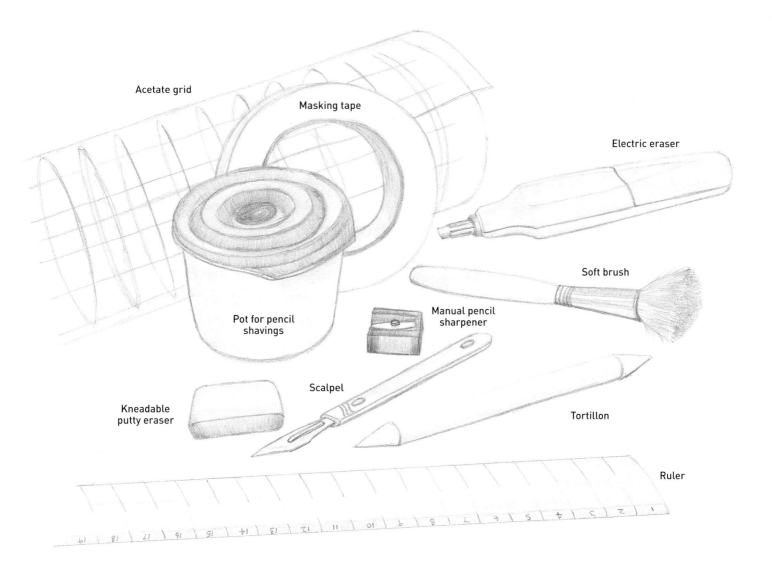

Acetate grid

Masking tape

Electric eraser

Pot for pencil shavings

Soft brush

Manual pencil sharpener

Scalpel

Kneadable putty eraser

Tortillon

Ruler

SURFACES

The sky really is the limit when it comes to surfaces on which to bring your drawing to life. It really boils down to experimenting, and remember that nothing is right or wrong; just find what works for you.

When I first started drawing seriously I imagined that all pencil drawings were produced on cartridge paper – a natural assumption, as it was the most common paper supplied for us at school. The more practised I became, the more I wanted to explore the effects graphite pencils had on different surfaces. I loved using rough watercolour paper, as it added texture to my work. More recently I got to experiment on stretched canvas due to an unusual request from a client booking a commission (the example I produced is below). Finally, I decided that smooth card suited my personal style after having tried mount boards and pastel cards. This is now my preferred surface material. It works extremely well and I always end up with a very clean and finely detailed drawing or painting.

As an aspiring artist you will discover other artists, past and present, that you may want to emulate or even surpass. Through studying their work and style, you will come to realize just what sort of artwork you aspire to produce and then you really have something to aim for!

I have decided to show you three different surface types, each with the same drawing produced on them.

Stretched canvas

This surface is extremely rough, with many bumps and dips, making it very difficult to control the pencil as you are working. It does respond quite well to a kneadable putty eraser, but this should be used mainly for lifting off unwanted pencil. Do not rub as this will smudge the graphite and leave a dirty mark. Unfortunately, it is quite hard to get the depth required on canvas as the surface begins to resist the graphite after a while.

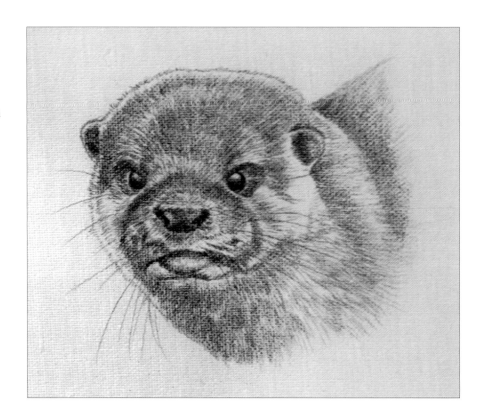

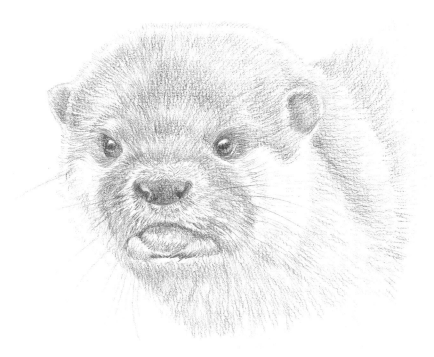

Rough watercolour paper

Although not as textured as the canvas, this cream-coloured rough watercolour paper still has quite a rough surface. This paper takes pencil more readily than canvas and more detail can be achieved by gradually building up. Again, a putty eraser can be used to lift off pencil but an ordinary eraser will also work, as long as it is clean and used gently.

Smooth card

This third study has been produced on a smooth white card. All of the otter studies on these pages were completed in the same way, but you can see how much more detail has been maintained and how crisp the lines are on card compared with the other surfaces.

The outline was first sketched with a 2H pencil, which was then used to create the first layer of fur and an undercoat on the eyes. Next, a 2B pencil was used to deepen the fur layers and darken the eyes, ears and mouth. Finally a sharp 4B pencil was used to give more depth all over. This was done gently, in gradual layers. Pressing too hard with a 4B pencil will result in a shine and the inability to deepen that area further. Working gradually may seem slow, but the results will be much more rewarding.

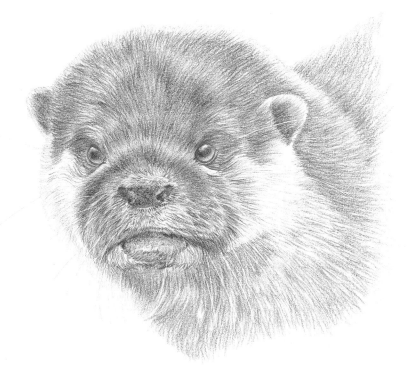

HOW TO START

GATHERING YOUR REFERENCE

There are a few ways of putting together reference material, but the easiest method is taking digital photographs. Certainly, you can use images from books to help with your drawing and also use photographs in books as references. However, nowadays animal photography is big business and you have to be very mindful of copyright when it comes to using other photographers' images or photographs from the internet. It is best to use your own photographs wherever possible, or you can try contacting amateur animal photographers to ask if you can use any of their images. Failing that, it will require a little bit of effort on your part and a few visits to your local zoo or wildlife park, to take your own pictures.

Digital cameras

Thank goodness for digital photography! Once upon a time I would eagerly take my films to be processed with high hopes, only to have them dashed when I collected my prints. Somehow they never looked as I had imagined, and I am sure I am not alone in that regard. Well, be disappointed no more. The immediacy of digital photography could not be better for the amateur photographer or artist. You can tell straight away whether you have taken 'the shot' or not and you can simply take more if the answer is 'not'.

I had to wait a while until I could afford an SLR (Single-Lens Reflex) camera, but this type of camera is far better than an automatic as there is no shutter delay when you are trying to take a picture of a moving subject. It is very frustrating to keep missing the perfect shot, and an SLR camera it is the best piece of equipment to ensure you capture it.

Most of these cameras come with a short distance lens only which is typically 18–55mm. I own a Canon 400D which is an exceptional starter camera and very user-friendly. If you want to take close up portrait shots you will need a basic zoom lens. A 70–300mm lens is the ideal one. It is fairly inexpensive, lightweight and does not increase camera shake if you have a steady hand or use a tripod.

If you don't have access to a digital camera, you can of course take photographs with your smartphone. Your phone is likely to be available at a moment's notice if the perfect picture opportunity presents itself. For example, even an iPhone 5S should be sufficient as the camera is approximately 8 megapixels. Obviously, anything newer than this model will produce even better quality images at up to 12 megapixels, or possibly more. You could even video your subject too to get a perfect three-dimensional view of the whole animal, in case your chosen photograph is lacking sufficient detail. If you are intending to enlarge your image to around A4 (8¼ x 11¾in) or even A3 (11¾ x 16½in) in size to then print out and work from, you need to keep your image as high quality as possible. Resist the urge to edit the image on the phone before you print it out; editing reduces the image quality and restricts how much you can enlarge the photograph. If you want to edit the image contrast or crop it on your phone before you use it, make sure that you save a new version into your photo library and keep the original higher resolution file intact.

Illustration of my SLR camera and a digital image taken with it.

PREPARING YOUR WORKSTATION

The best way to start is to be fully prepared. I can guarantee I will just get comfortable and then find I am missing something I need to start my drawing! Invariably, it will not be the last time I have to extricate myself from my desk and go in search of an essential tool – so be sure to be ready from the start.

I have invested in office-style storage to help me become more organized and enable myself to put away any completed work in a safe place. This equipment need not be expensive, and the best place to look for second-hand items is online. I have a set of drawers and a small cabinet that looks like a mini wardrobe, with shelving inside.

It is not imperative to have an art desk. When I first started, I did not own a desk and so I used canvas boards as my surface and taped my paper or card to the untextured reverse side. Another cheap option is to cut some MDF board to size and use that as your board to lean upon.

It is always better to work at an angle, as you begin to lose a sense of proportion and perspective by working flat. The easiest way to do this is to sit at a table and rest the top of the board on the table edge. Place the bottom of the MDF in your lap and you have an angled working position. It is almost impossible to make this angle too acute but do make sure you are comfortable.

Before you begin, you need to make sure you have all the pencils you require, your eraser, sharpener and pot for sharpenings, reference pictures, masking tape and any other materials to hand. Use some masking tape to attach the corners of your card or paper to the board, to prevent any movement.

It is important to keep your paper or card clean as you work, so use a piece of paper to rest the side of your hand on as you move across the card, to prevent smudging your work.

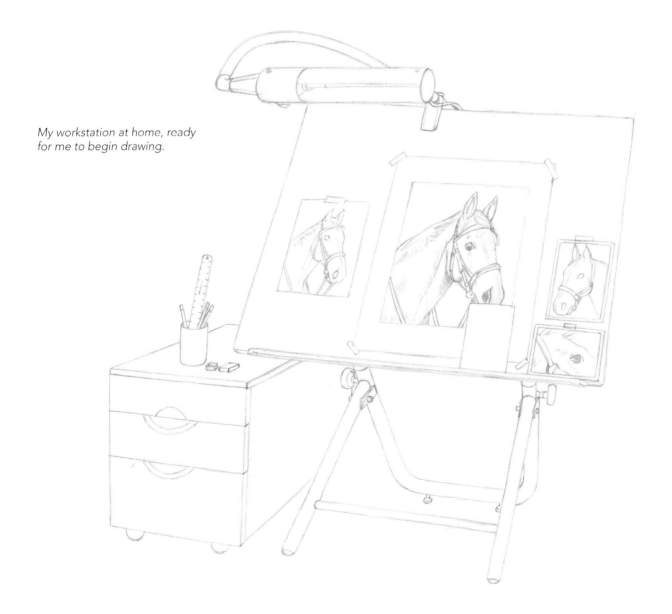

My workstation at home, ready for me to begin drawing.

PLANNING YOUR PICTURE

Taking reference pictures

If you are lucky enough to be able to meet your subject and take your own photographs, you need to make sure that you have enough good quality reference shots. The same principles apply to being supplied with images from which to work, but this method means it is slightly harder to get exactly what you want.

Regardless of the method you use, your aim should be to try to build up a three-dimensional image of your subject by correctly selecting reference images.

As an amateur you often have to learn by your mistakes, and I am speaking from experience. I would often get back home after taking photographs of my subject and realize that none of my pictures contained the animal's tail for instance, or a good clear eye or nose shot! If you are taking the photographs yourself, here are a few tips to remember:

· Try to take any photographs outside in natural light.

· If the animal is excited, wait patiently for them to settle down before beginning.

· Take treats or squeaky toys where appropriate to get the animal's full attention and focus on you.

· Ensure that you take full body shots and close-up head shots as well.

· To help you later on, get some good close ups of eyes, ears and noses and not forgetting tails.

· Do take shots from both sides of the animals head so you can decide later on which shows their 'best side': we all have one!

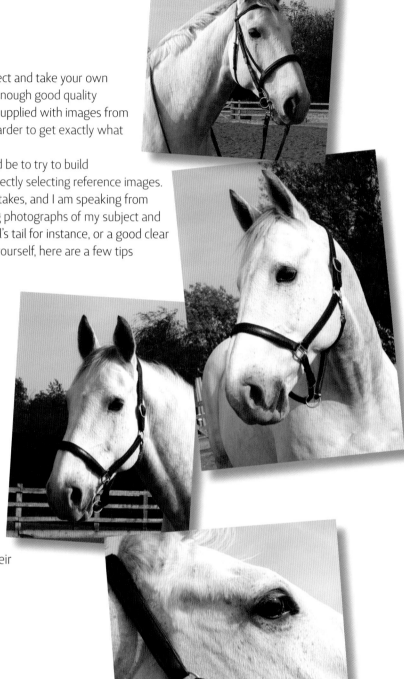

Planning the composition

If you have considered your reference photographs carefully, this part should be fairly straightforward. When you look through your images, the best thing to do is to begin shortlisting them for preference. You will then be better placed to select the best photograph from which to work, having eliminated the others.

As an example I am using a horse to show you the reference material that will help me complete this particular portrait and the other images that will provide me with further information as I begin to work. The next step is to draw out your animal's outline onto your chosen surface.

TRANSFERRING THE IMAGE TO PAPER

The grid method of transferring your image onto your surface is used by artists all over the world and is not to be considered cheating: you will require skill to transfer the image correctly. If you are like me, you will be so keen to start your new portrait or drawing that if any part of the planning stage can be eliminated you will jump at the chance. With this in mind I am going to explain the grid method assuming that you are beginning with your photographic reference the correct size and that no enlargement is required.

When I first started using the grid method, I drew a grid over my reference picture and then a corresponding grid on my paper. There is nothing wrong with this but it does ruin your reference picture. Instead I recommend creating a permanent grid that you can reuse. This is the easiest way to transfer your selected image to your paper or other surface without damaging your reference.

The majority of the portraits I produce are smaller than 40 x 60cm (15¾ x 23½in), with most around 30 x 40cm (11¾ x 15¾in). I now work from photocopies that are the exact size I wish my finished portrait to be. This eliminates the need for enlarging by grid method which can be complicated.

TIP

These instructions are for a 30 x 40cm (11¾in x 15¾in) grid of 2cm (¾in) squares, but you can easily alter the size for larger pictures, or the size of the grid for finer or broader detail.

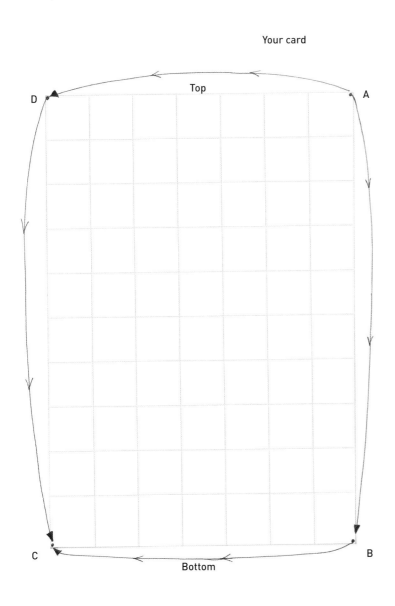

Your card

Top

D A

C B

Bottom

YOU WILL NEED:

- Piece of transparent film or acetate, 30 x 40cm (11¾in x 15¾in)
- Slim-tipped black permanent marker pen
- 60cm (23½in) ruler
- A set square
- A solid surface to work on

Creating a permanent grid

1 Use the set square and ruler to draw a 30 x 40cm (11¾ x 15¾in) rectangle on your film or acetate to give you a shape to work within.

2 Starting in the top right-hand corner of your acetate (A), use the pen to mark in 2cm (¾in) increments towards the bottom right-hand corner of the rectangle (B).

3 Next, move back up to the top right-hand corner and mark in increments of 2cm (¾in) across to the top left-hand corner (D).

4 Now, mark down from the top left-hand corner (D) in 2cm (¾in) increments to the bottom left-hand corner (C).

5 Go back to the bottom right-hand corner (B) and mark back across to the bottom left-hand corner (C) in 2cm (¾in) increments.

6 Finally, use the ruler and marker pen to carefully join up all your marks into horizontal and vertical lines. You will now have a permanent grid with which you can overlay your reference picture.

Preparing your paper or other surface

When drawing your grid on your paper to transfer your image, the key thing to remember is use a hard pencil (ideally a 2H) and to use very little pressure from your hand. Remember that you will want to erase these grid lines when you have finished drawing out your image. Any pressure on the pencil will make this very difficult to achieve. If you use a soft pencil and you try to use an eraser to erase the lines, the pencil is more likely to smudge and leave a dirty mark that you will not be able to remove.

In this example I am using smooth white card to work on. You need to count the amount of horizontal and vertical squares on your reference picture grid to make sure you have the same number on your permanent grid and your paper grid.

1 Establish a rectangle of the correct size on your surface; in this example, 30 x 40cm (11¾ x 15¾in).

2 Draw your grid in the same way as you did for your permanent grid but using the 2H pencil.

3 You can now attach your grid to the front of your photocopy using some masking tape. Now you will have your film grid taped gently over your reference photocopy and a matching grid on your paper or card.

TIP

Position your film grid so that details such as eyes are on the line between two squares rather than dead centre within a single square. It is much easier to plot the position of details like this between squares.

Transposing the image

The aim now is to transfer the information from your film grid onto your paper, square by square. The best way to start is to use your grid to plot the highest point of the animal, which in this case is the horse's right ear. Count how many squares from the top of the grid and how many squares in from the right-hand side of the film grid the ear is placed. Plot these corresponding points on your card grid so you know where to begin. Double check your measurements by counting the number of squares down from the tip of the ear – or where you want the portrait to end – to ensure you have enough room on your card and that the portrait appears in the right place on there too. Ideally there should be some empty space above the ears or the portrait will look too cramped. Check also that there is the correct number of squares widthways on your card.

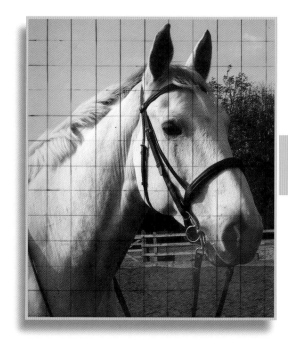

1 Beginning with the square containing the tip of the right ear, copy what you see in the film grid square into the corresponding square on the card.

2 Work down and around the outline of the horse first. As you work, ensure that no squares have been missed out by checking the number of squares on the grid between features such as the ears and the nose, or the nose and the back of the neck.

3 Eventually you will end up with an outline of the horse on the card. After checking that you have transferred all of the image across, gently erase all of your grid lines with a clean eraser.

TIP

The best way to measure within each square as you are working is to picture your square split into quarters. This helps to break up the space and enables you to copy the information more accurately. If this helps but it is too complicated to do in your head, try picking a section of your grid and divide some of the squares into quarters with a pencil. Another way is to simply have another smaller grid made up of 1cm (⅜in) squares to help with important details such as the eyes.

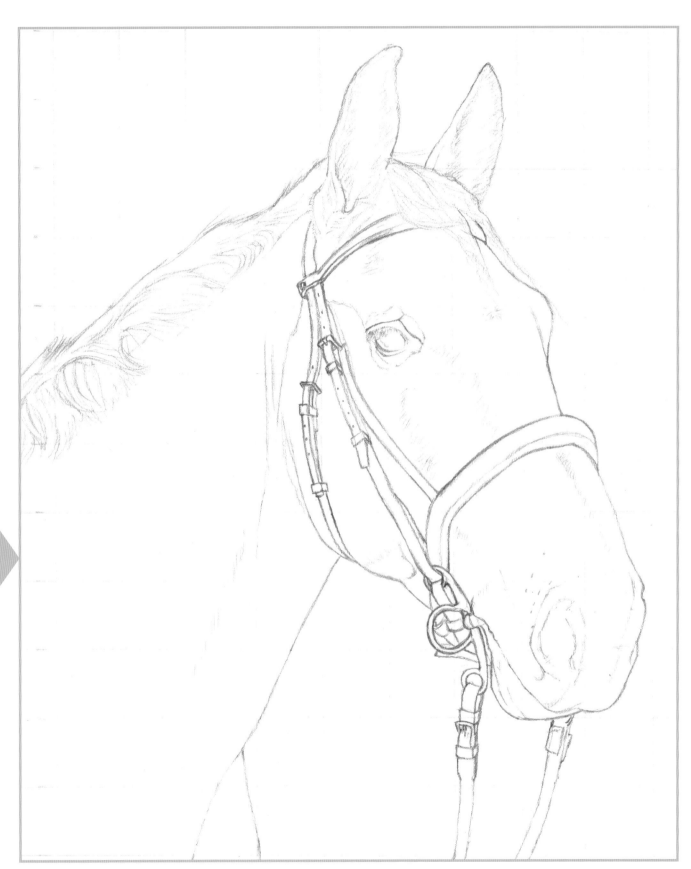

Dee
30 x 40cm (11¾ x 15¾in)
The outline completed and ready to shade.

WORKING WITH REFERENCE PICTURES

Drawing by eye is often considered the hardest thing to do. If you pass a pencil to someone, a common response will be that they can not draw, even before they try! To successfully draw by eye, whether it is copying from a picture or drawing from life, you must be competent at two things: perspective and proportion. Without these ingredients your drawing will not be correct.

To draw well, it is critical to ensure that the photographic reference from which you are sketching or drawing is the best it can be. Your drawing will only be as good as your reference material, and there are many ways of taking photographs of a subject; not all of them are good. These pages show you some examples of good and bad perspective and proportion for you to compare and contrast.

Perspective

The photograph of the wolf on the left would not make a good reference picture. The angle of the photograph makes the wolf appear stumpy-legged and the size of her head has been exaggerated. If you tried to copy this image, it would be very hard to draw the angle of her legs, and this is something to consider when choosing your reference photographs. Although this particular wolf, Tatra, is relatively short and compact compared with other wolves, this is not a good photograph of her.

The second picture (right) is another one of Tatra. This time the picture has been taken slightly above and side-on to her. It is more flattering, showing the length of her body, and there is no foreshortening of her front legs. Her head is also in proportion to her body and the whole effect is much more pleasing to the eye.

TIPS

- Practise by drawing sleeping pets.
- Start with rough lines to complete the outline.
- Make sure you are happy with your outline before you get distracted by details.
- As you sketch, keep measuring each part of the body against other body parts to maintain the correct proportions.
- Work on an angled surface so you maintain your perspective as you work.
- Drawing in ballpoint or ink pen can be good fun and leaving in your plot lines can add interest to your finished drawing.
- Finally, practice makes perfect. It really is the only way to improve your freehand drawing.

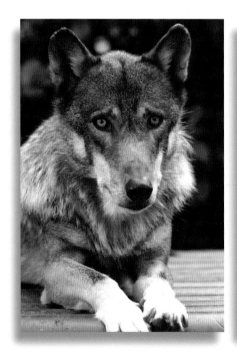

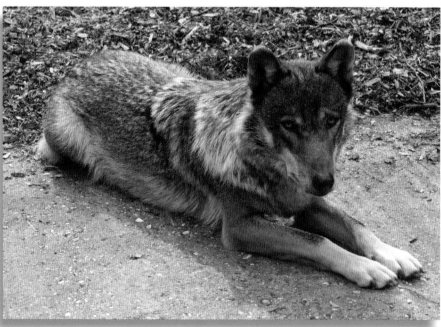

Proportion

This is the other component of a good freehand drawing. Top right is a photograph of Dee, looking stunning but not in proportion. The position I was standing in when I took the photograph was definitely too close and it appears as though I am nearly as tall as him. The effect has shortened his legs so that they are no longer in proportion with his body. His head is pushed forward and as this is the closest body part to the camera, it now looks too large in comparison to the rest of him. As he is positioned head-on to me, there is nothing for the eye to gauge the size of his head against and so the result is not good.

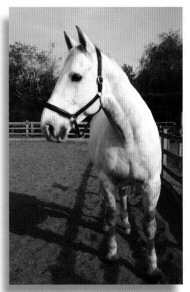

The second picture below is again of Dee, and in a similar pose. However, this time his whole body is at an angle to me, giving the image more perspective against which he can be measured. His head is turned side-on and this makes his neck look longer. This angle has not foreshortened his legs and it is much easier to see how tall he is in comparison with his width. In the first photograph the back half of his body is obscured, but in the second even his tail is in view. All in all, this is a much better picture from which to work.

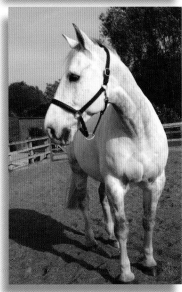

Observation

Being observant is something we all like to think we are good at, and it is easy to convince yourself that you will be able to remember specific details when you are back at your desk. However, observation for drawing is more complex.

I am very careful to observe the animals' mannerisms and personality traits but as much as I like to think I can commit these details to memory, it rarely works out that way. I take many hundreds of photographs to enable me to complete detailed commissions of all sorts of animals.

My reference photographs become my map of that particular animal. There are always particular markings or blemishes that are unique to them and must be replicated in the portrait to ensure that the portrait is recognizably that specific animal.

Good observation includes understanding fur direction, muscle tone and bone structure. This may sound overwhelming but it is really just about using your eye to study things more closely, and more carefully.

Ready to Begin

Now that you are ready to start drawing, there is another leap in technology that can work in your favour if you are working from a digital photograph. If you own a tablet or a good quality smartphone why not open up your reference photograph on there, so that you can view it close up as you are working?

Even if the printed hard copy image I'm working from is really good quality, there will always be something, for instance eye detail, that I could do with seeing more closely. That's where my trusty tablet comes in: I am able to zoom in on those hard-to-see areas and find and record textures and finer features I may not have seen as clearly on the printed copy. In addition, if the image on my tablet is too dark, I can also use a picture editing app (such as Adobe Photoshop Express) to lighten it a little more. I'm then ready to go.

DRAWING KEY FEATURES

When it comes to drawing animal faces, there are lots of different shapes once you start looking. Some have their eyes closely set together at the front, some have eyes either side of their head to get full peripheral vision; there are pointy faces, stout faces and some that are very unusual looking indeed!

The following features in this chapter are just a few captured from different types of animal that you may want to draw. This will hopefully give you a good understanding of the variety of eyes, noses, ears, hands and feet shapes and how to draw them.

Mongoose

All of the mongoose's main features are situated within a very small area, on the front of its head. Having eyes at the very front of their face is an adaptation that allows them to see the coast is clear, without having to poke their heads too far out of their tunnels. It also benefits them when eating their favourite food – eggs. As only the front of the face will be in the egg, they can keep the fur clean on the rest of their head. Small ears set towards the back of their heads help to limit the amount of debris collected in them while digging and travelling underground, and also enable them to hear while they are busy eating.

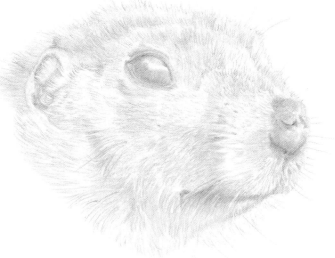

Prairie dog

These animals are foragers, so need their eyes set further back on their heads to help them stay clear and free of debris as they dig or burrow for food. Prairie dogs may have small ears but their hearing is very sensitive, especially at a low frequency; this allows them to detect predators early, especially when in their burrows.

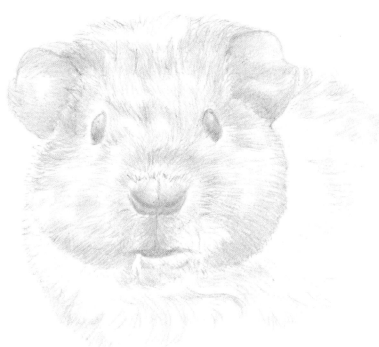

Guinea pig

A guinea pig's face is quite compact, with all its features situated fairly close together and near the front of the face. Their ears are small and petal-shaped, their eyes are set on the sides of their heads and their mouths are small and triangular in shape. The fur length on guinea pigs varies quite considerably; this particular one had fairly dense, short fur. They are a lot of fun to draw thanks to their quizzical expressions, and they make the perfect pet from which to practise your drawing skills.

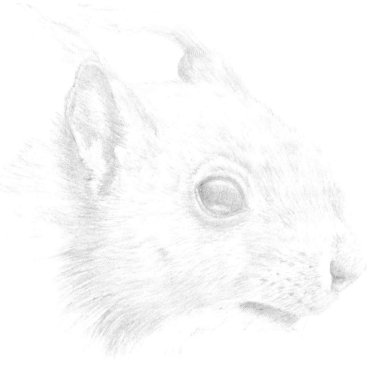

Red squirrel

All squirrels have the same narrow head shape, with the nose situated at the very tip of the face. Their black eyes are at the sides of their heads; this helps widen their peripheral vision but it also means they can't see directly in front of them. Squirrels also have a large number of whiskers, which are constantly twitching due to the vibrations they can feel in the air. These signals keep them informed about any impending dangers in the vicinity.

EYES

Animal eyes vary greatly in shape and size when you start to look at the varieties. You can be forgiven for assuming that all cats' eyes are the same shape and make up. However, when you study them more closely you'll notice that your domestic cat's eye has a 'slit' shaped pupil compared to the big cat species that have circular pupils.

Research has found that cats with 'slit' shape pupils are generally 'ambush predators' who are actively hunting during day and night, so this particular shape pf pupil helps them to see in dim light, yet not get blinded by the midday sun. Cats with circular pupils are found to be mainly 'active foragers' who chase down prey and need the maximum amount of light to enter the eye.

Domestic and wild dogs have very similar shaped eyes but, compared to humans, their colour spectrum makes colours appear less radiant. It was originally thought that dogs were colour-blind, but this isn't the case, they simply have fewer colour-sensitive cone receptors in their retinas than us. It has also been proved that they can't see as sharply as us humans, seeing typically what we'd see at 23m (75ft) at a 7m (20ft) distance. This explains why domestic dogs sometimes appear to not recognize their owners from a distance, then suddenly break into a waggy-tailed run as they get closer and their vision becomes sharper!

Even prey animals have special eyes. I bet you didn't know that grazing animals are actually keeping an eye out for potential predators, even though it appears they are looking at the ground – when they drop their head, their pupils rotate by up to 50 degrees to stay horizontal! They also have very good vision in the corners of their eyes, enabling them to dart sideways and make a quick exit with a moment's notice.

Chameleons have the most extraordinary eyes as their eyelids are fused and cover almost the whole of the eyeball, with only a small hole for the pupil to show through. With its eyes moving independently of each other, it can scan for danger and look for prey in different directions at the same time – very handy!

Here are just a few of the different eye shapes to be found in the animal kingdom.

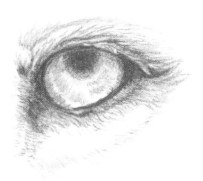

Lion

Lions are born with blue eyes. Newborn cubs are blind initially, only beginning to see at around three or four days old. The eyes start to change colour to the beautiful orangey brown that we know and love around the age of two to three months old. Lion eyes are quite large and are nearly three times as big as ours. Like our domestic cats, lions have an extra eyelid that helps to clean and protect the eye. In addition, there is a reflective coating at the back of the eye that enables them to reflect moonlight; this makes their eyesight eight times better than ours. The patch of white fur under their eyes also helps with their vision, reflecting more light back into the eyes.

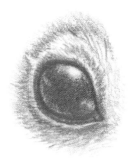

Red squirrel

Squirrels have very large eyes in proportion to their small, narrow faces, and they are very round and set much closer to their ears than their nose. Squirrels also have very keen eyesight: their peripheral vision is just as good as their focal vision, meaning that they can see what is above and what is beside them without having to move their heads. This makes it extremely difficult to sneak up and surprise a squirrel.

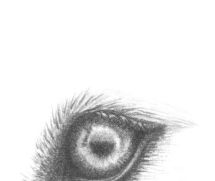

Wolf

Wolves have similar-shaped eyes to that of other predators – teardrop shaped, with a large iris and full pupil. Wolf cub eyes are blue at birth and then turn completely orange-yellow by the time they are around eight months old. Their eyes are situated at the front of their heads to give them a wider field of vision, which is just under 180 degrees. For this reason they have exceptional eyesight, and are able to detect the slightest movement of any prey species in front of them.

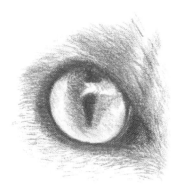

Red fox

A fox eye is unusual in its shape, with the tear duct pointing down towards the nose and the rounded section going up towards the cheek – almost a tear-drop on its side. They have a variety of amazing features to help them hunt, but their eyes are specially adapted to enable them to hunt at night. Fox eyes are very much like those seen in our domestic cats, with their vertically slit pupils and extra layer of light-sensitive cells to give them sharper vision. Fox eyes are beautiful to look at with their black outlines and liquid, amber irises.

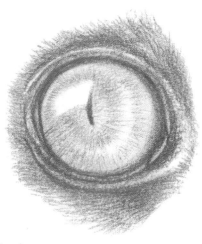

Loris

A loris eye is very large in proportion to its face, and circular in shape with a vertically slit iris. Because the loris' eyes are frontally positioned, they have binocular vision and so a greater perception of depth. To ensure it has excellent night time vision too, a loris' eyes have a specific reflective layer that both protects the eye from light while reflecting it at the same time – much in the same way that a cat's does.

GIRAFFE EYE

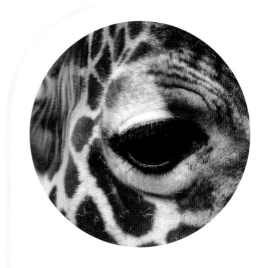

The giraffe may be one of the most unusual looking residents of Africa's dry savanna, but they are also the tallest land animal and by far the most graceful to watch. They have excellent eyesight and can spot predators miles away while spending their day stretching up to devour the leaves and buds of acacia trees with their long tongues, which can be up to 53cm (21in) in length! They spend most of their time eating – they can eat up to 45kg (2¼lbs) of twigs and leaves in a day but, luckily, they only need to drink every few days because of the fantastic moisture content in their diet. Their eyes are stunning, with long, dark, spiky lashes and liquid-like pupils, so what could be a more perfect project for drawing?

For this step by step you will be using different grades of pencils in layers to build up the depth in this drawing. With this in mind, you will need to apply each pencil with gentle pressure so as not to fill up the surface and prevent the next grade of pencil from being effective.

MATERIALS

Smooth white card, A4 (8¼ x 11¾in) in size: I use Clarefontaine

2H, 2B, 3B and 4B graphite pencils

Pencil sharpener

Putty eraser

Spare piece of A4 (8¼ x 11¾in) paper, to rest the ball of your hand on while you work

To download and print out the full-sized photograph of the image above, please visit the web page:
www.lucyswinburne.co.uk

1 Outline To begin, choose a 2H pencil to draw the outline of the eye and the surrounding area, using the reference photograph. Try not to get bogged down with too much detail at this point; a basic outline is all that is required.

TIP

Do not forget to have a spare piece of paper ready to rest your hand on as you work to prevent smudging.

2 **Adding more detail** With the same 2H pencil, begin to shade in your drawing, beginning wherever you feel most comfortable. Keep the pencil pressure light and feathery – pressing too hard will create indentations that you won't be able to shade over with the next pencil – and use the reference picture to see the hair direction, skin creases and skin markings. When you come to shade in the eyeball, start from the outer edges, softly working inwards towards the centre of the eyeball in a circular motion. Shade very lightly over the areas where the highlights appear in the eye, so that these places remain a lot lighter than the rest of the pupil.

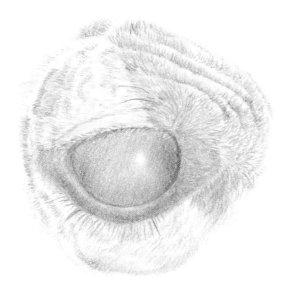

3 **Adding depth** Now select a fairly sharp 2B pencil. Go back over the same areas as with the 2H pencil in step 2, again using the pencil quite softly. When filling in the eyeball, remember that this is a three-dimensional object and try to shade from the outside edges in towards the centre of the eye, to create a rounded shape to the shading. Again, leave a small area of lighter pencil shading where the highlight will be in the pupil. This highlight should not be left pure white or it will appear too stark against the rest of the pencil shading – it just has to be lighter than the rest of the eye.

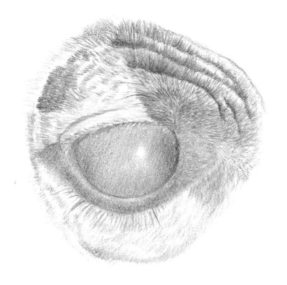

4 **Tone** Sharpen your 2B pencil and go back over your drawing, adding another layer of shading over the previous layers, until the depth resembles something similar to this stage drawing. Begin to darken the longer hairs in the creases above the eye, so they stand out more and add more interest to the skin markings. Continue to build up the eyeball slowly, ensuring you keep the highlight.

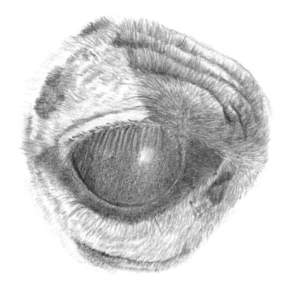

5 **Shadow** To darken the eye and surrounding area further, take the 4B pencil and use this to go back over the markings, eye and surrounding eye area. Once again, take care not to obliterate the highlight you have created. Sharpen the pencil and flick some long eyelashes out from the top and bottom eyelids using short, fluid motions. You'll notice that the eyelashes look as if they have lighter areas between them where the eye is showing through – this will help make lift out more when you darken them for the last time in the next step.

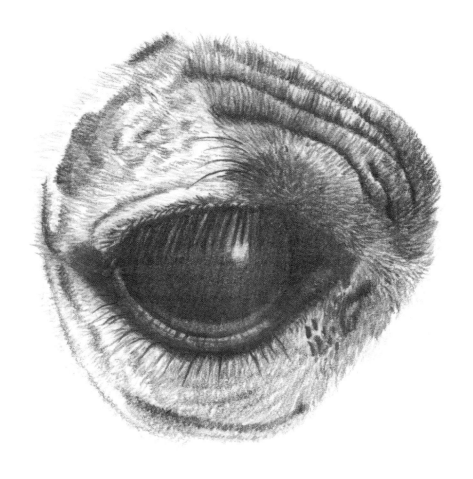

Finished eye

Select the 2B pencil again and go back over the darkest areas of the eye, mainly the eyeball and surrounding eye area. The 2B is used here, as it is a harder pencil and will help you achieve the added depth required. Then, go back over the eyelashes and any prominent hairs with a sharpened 3B pencil. Finally, use a putty eraser shaped by hand into a soft point, to gently rub out a little of the highlight in the eye, creating more impact!

EARS

Just as there are many different shaped eyes, there are also a diverse range of ear shapes and styles; from massive to tiny, round to tall, and hairless to fluffy.

So let's start with the the animal that we all think of straight away that has the largest ears – the African Elephant. Their ears can measure 1.83m (6ft) from top to bottom and 1.53m (5ft) across – they need to be this big so that the elephant can regulate its temperature, as the ears dissipate the heat. The cooling factor is also assisted by the fact that they act like huge fans when flapped against their bodies.

Animals with small ears generally live in colder climates and don't need to dissipate heat, so their ears are smaller to conserve warmth.

In contrast, you may have seen pictures of the Fennec Fox which has massive pointed ears. Their ears are built this way to pick up the micro-sounds from beneath the earth of its rodent and insect prey. Red foxes also have quite big ears to enable them to hear their prey when hunting, but it is their night vision that does most of the work.

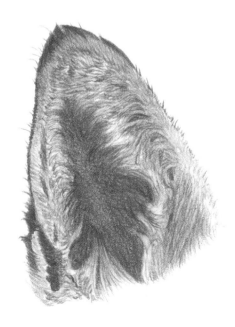

Red fox

The pointed ears of a red fox are very mobile and can move independently of each other, allowing them to pinpoint the source of a particular sound. To enable them to hunt effectively in low light, they have extremely sensitive hearing that can pick up low frequency sounds, especially the tiny noises made by their prey. The outer edges of the ears are covered in short hairs, but their inner ears contain a dense border of long hairs that help prevent dirt particles entering the ear canal – so, when you draw a fox, remember to use slightly longer pencil strokes for these longer inner-ear hairs.

African wild dog

African wild dog ears are large, rounded and lined with muscles that enable the dogs to swivel their ears like satellite dishes, so that they can hear the tiniest of sounds. Undoubtedly, their ears make them stand out from other types of wild dogs found around the world, and are the feature that you most remember about them, along with their fantastic coat. The outer ear is covered in short, dense hairs, whereas the inner ear has longer, finer hairs. In addition, there are lighter tufts of hair that sprout from the base of the ear that you will need to draw prior to sketching the others, and which you will then need to work around gently as you add more pencil, to darken the inner ear.

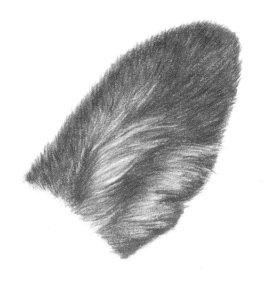

Zebra

Although zebras and horses are similar in appearance generally, zebra ears are much rounder and more pronounced. Zebras have also exceptional hearing. Like the other examples on this page, zebras can rotate their ears in all directions. The back of the ear is covered in short black and white hairs, but the inner ear is made up of lots of fine hairs that travel deep inside. It can look a little bit complicated to replicate in pencil, but if you take your time and keep referring regularly to your reference photograph it will all make sense.

Rhino

Rhinos have very poor eyesight. To compensate for this, they have excellent hearing and good sense of smell. Their ears are shaped like cups and can rotate independently of one another, and both of these qualities allow them to hear clearly and catch sounds all around them. The most important noises rhinos need to hear are the distress or warning calls of birds, as these usually signal danger; their specially adapted ears then enable rhinos to react quickly to any imminent danger. The skin on the ear follows the same texture as the rhino body, and so will require building up through several layers of pencil.

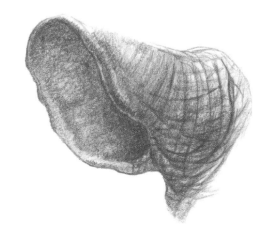

AFRICAN WILD DOG EAR

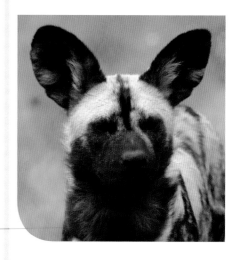

Often known as the painted dog due to its unusual mottled coat, the African wild dog is an endangered species. As a pack these dogs are not unlike wolves in their hierarchy – the alpha pair are in charge and are the only ones allowed to breed within the pack. They are extremely social animals and show a fascinating level of empathy, feeding sick or elderly pack members who are unable to hunt. African wild dogs have an 80 per cent success rate in their hunts because they are so well-coordinated and communicate with one another effectively. They are one of my favourite animals, and as their ears are quite a feature, I couldn't resist using them for this step by step.

MATERIALS

Smooth white card, A4 (8¼ x 11¾in) in size: I use Clarefontaine

2H, 3B and 6B graphite pencils

Pencil sharpener

Putty eraser

Spare piece of A4 (8¼ x 11¾in) paper, to rest the ball of your hand on while you work

To download and print out the full-sized photograph of the image above, please visit the web page: www.lucyswinburne.co.uk

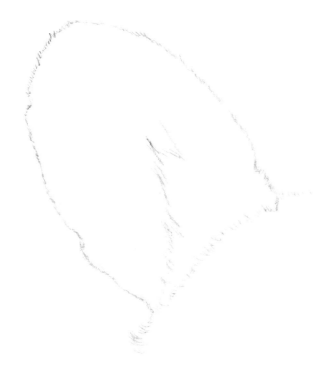

1 Outline Draw the outline using your chosen method of grid, using a 2H pencil that has a slightly worn point, to prevent any scratchy lines forming. When the outline is established, if the pencil lines are too dark knock them back gently with a putty eraser and soften any hard edges.

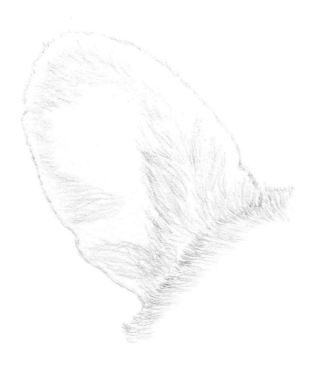

2 Introducing detail Lightly use your 2H pencil to add all of the lighter hairs within and at the base of the ear, where it is joined to the head. Don't press too hard with this pencil or you will indent the paper. The dark, soft grade pencils you will be using later will make these indentations stand out as harsh lines when you shade over them and you can't get rid of them.

TIP

Don't fill in the very dark areas of the ears with the 3B at this point; you will be using a darker grade of pencil for this.

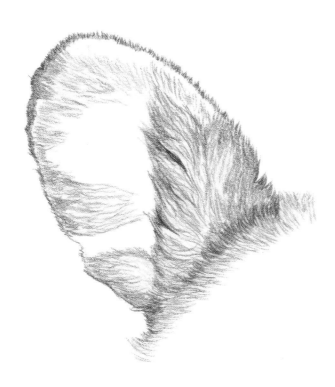

3 Tone Make sure you have your spare paper at the ready to rest your hand on as your work, as you will be using a darker pencil. Sharpen the 3B pencil and use it to darken the outline of the ear gently, along with the lighter hairs at the base of the ear. Next, start to shade around the lighter hairs within the ear, so that they stand out. To do this, shade in between the hairs to break them up, as you can see in the image to the left. Don't fill in the very dark areas of the ears with the 3B as you will be using a darker grade of pencil for this.

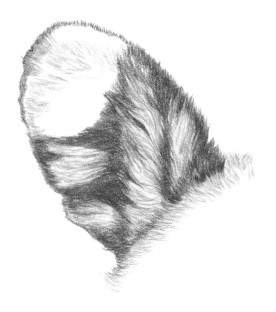

4 **Shadow** With a sharp 6B pencil, start to build up the dark sections in the ear between some of the lighter hairs to create sections. There's no need to press too hard with your pencil at this stage, as you will go back over these areas again later with the same pencil. At this point, all you need to do is begin to 'map out' the dark sections and make sure the light hairs stay visible. Take your time as you work on this first layer, as this pencil is very soft and you could easily go over the outline of the ear, spoiling the detailed edges. Throughout, don't forget to rest the side of your hand on your spare piece of paper to protect your surface. In addition, look out for small pieces of graphite pencil that will shed from the tip; they need removing before they get stuck on the surface, or you may smudge them and then find them impossible to remove with a putty eraser. Simply blow these fragments gently off the background.

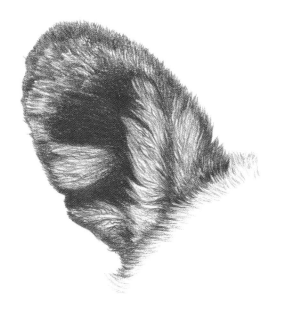

5 **Texture** Return to the sharp 3B and shade in between the lighter patches of hair, breaking them up to help distinguish them into patches of lighter hairs. When you have done this all over the inside of the ear, sharpen the 6B and begin to go back over the darker areas. Again, be careful when you do this to avoid going over the edges of the ear. Blow away any excess graphite too, as soon as you see it on the card. You will also need to clean the paper you are using to lean on with the putty eraser, as the back of it will have likely picked up graphite fragments and will transfer it back onto your drawing.

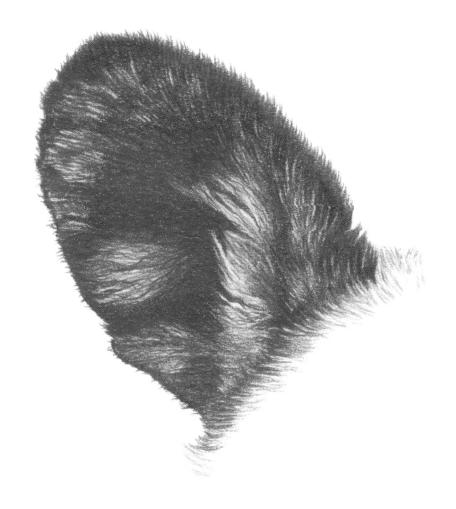

Finished ear

Continue to work with the 6B to darken the inside of the ear where required while resting your hand on your spare paper. Use a sharp 3B to go back into the lighter hairs and break them up more, and also blend them a little where necessary into the darker sections of hair. Add some more tiny hairs around the outer edge of the ear with the sharp 3B pencil. To finish, if the middle section of lighter hairs has been swallowed up by the darker section, you can shape your putty eraser to pick off some of the graphite and make them stand out more.

NOSES

When it comes to noses, the variety can be quite impressive! Have you seen ever seen a mole's nose? This spindly, double star shaped appendage is unique in design and serves a very important purpose. Being extremely sensitive to touch with its 25,000 sense receptors, its nose scans its tunnels for food, sweeping backwards and forwards at an incredible speed of a dozen times a second. The whole process from when it discovers food to eating takes a fifth of a second – so now you know, there's nothing slow about a mole!

Pigs are another animal with quite a special nose (snout), as it is approximately 2,000 times more sensitive to smell than the human nose. They also use it as a tool for turning the ground over to root for food, so it's a very necessary piece of kit.

Other remarkable-looking noses belong to animals such as the koala, the proboscis monkey, with its rather comedic rubber looking nose and the echidna, also known as the 'spiny anteater' with its long fleshy nose and extra-long tongue.

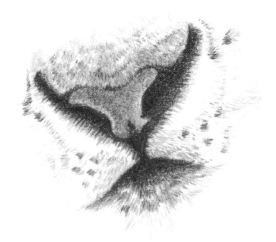

Snow leopard

A snow leopard's sense of smell is not as good as its eyesight, which is far superior, but it does rely on its nose to help it identify other cats in the area, sniffing the scent trails they leave behind. Most of the big cats have similar nose shapes, and their noses are positioned at the tip of their muzzle. The most important thing about drawing a big cat's nose is to shade in and create a textured surface from the very start.

Black sheep

Sheep have a brilliant sense of smell as they need to know what all types of predators smell like – not that they have too many to worry about in the UK! Female sheep also use their sense of smell to help locate their lambs, and rams use their noses to sniff out ewes in heat. In addition, sheep need a good sense of smell to find water and locate their feed and good pastures. The design of a sheep's nose isn't too different to that of a big cat's, except the 'V' shape is more pronounced, and with more hair and less texture to the surface.

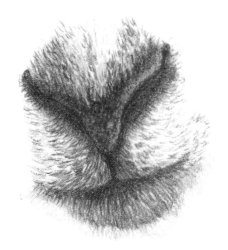

Pig

Pigs have an amazing sense of smell that they use to locate food sources. They have a large, round disk of cartilage at the tip of their snout which is connected to muscle, giving it extra flexibility for rooting around on the ground for a snack. Of course, a pig's snout is very unique looking with its flat, round end and the two holes for nostrils on the front of its extended muzzle, so drawing this nose is a very different process. You will need to take extra special care with the perspective of the drawing, so that the nose looks like it belongs there rather than looking like an after-thought.

Grizzly bear

Bears in general have the greatest sense of smell of any animal on earth – better than a dog's. A bear's nose is so sensitive that they can smell an animal carcass upwind from a distance of approximately 30km (20 miles) away. The shape of their nose is very unusual, as it is quite upturned and could be likened to a mushroom from the front. As the nose is very dark, you could start shading with quite a soft pencil, like a 4B, and then finish off with a 6B to darken sections further. Then, use a putty eraser to lift off pencil marks to indicate highlights.

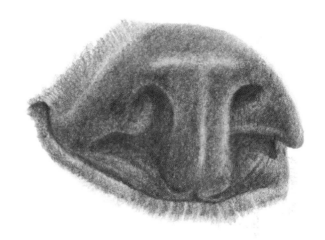

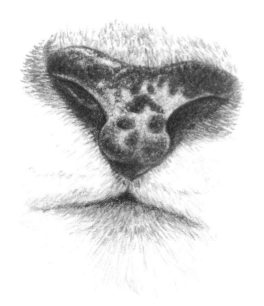

Mountain lion

This big cat's nose is very similar to that of the snow leopard, but the pigmentation around the nostrils contains a greater variety of colours. Like other big cats, a mountain lion's sense of smell is very poor compared to its excellent vision and sensitive hearing. Sketch with a 2H pencil first to build up a light layer on the nose, using small circular movements to create texture, before darkening with soft B pencil.

BUFFALO NOSE

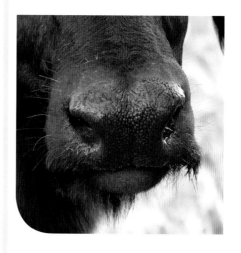

The spectacular buffalo is my choice for the nose step by step in this section. I felt that their large, wet nose was a perfect choice for drawing! They are amazingly silent even in huge herds, arriving out of the blue with no warning and disappearing just as quickly and quietly. I have witnessed this with a herd near a water hole in Kruger Park in South Africa, which simply vanished when I looked away briefly. It was an incredible experience that I wouldn't have believed unless I'd seen it! Yes, they do tend to look very grumpy, but they are still magnificent looking, with their characterful faces and their busy, resident bug catchers – the hardworking little oxpecker – always somewhere on their bodies. Allegedly, Buffalo have exceptional memories and will remember the face of someone who has hurt them in the past (for example a hunter) and attack them if they meet them again in the future! They will also kill the cubs of lions that have hurt or killed a member of their herd in the past if they get the opportunity.

MATERIALS

Smooth white card, A4 (8¼ x 11¾in) in size: I use Clarefontaine
2H, 2B, 3B and 4B graphite pencils
Pencil sharpener
Putty eraser
Spare piece of A4 (8¼ x 11¾in) paper, to rest the ball of your hand on while you work

To download and print out the full-sized photograph of the image above, please visit the web page: www.lucyswinburne.co.uk

1 Outline Draw a basic outline, using whichever method suits you best, with a 2H pencil that has a slightly worn point to prevent any scratchy lines forming. When you have your outline, if it is too dark knock it back gently with a putty eraser and soften any hard edges.

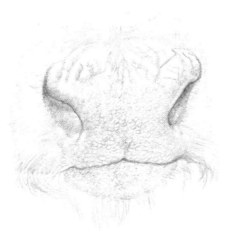

2 **Adding detail** Use your 2H pencil to begin shading in the nose, making sure you keep looking at your reference picture as you work. Begin to build up the pitted texture on the front of the nose by sketching small circles. This texture needs to be added right from the start, so that you can build on it as you add each grade of pencil in the subsequent steps. Note that the texture of the buffalo's muzzle is made up mainly of short hairs which lengthen the closer you get to his mouth.

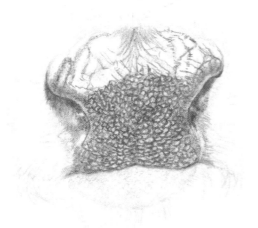

3 **Texture** Sharpen the 2B pencil then, on some rough paper, slowly turn the pencil clockwise to take the sharp edge off the tip evenly, to prevent any harsh lines when drawing. Go back over the front of the nose again as you did in step 2, continuing to build up the honeycomb-like texture, but this time adding more depth. There are some highlights along the edge of his nostrils that need to be kept quite light; if they are darkened too much, gently use a putty eraser to lift them out again. Work back over the rest of the nose carefully with the 2B but taking care not to press too hard; you can always add more to darken, but it is harder to remove if you press too hard too soon.

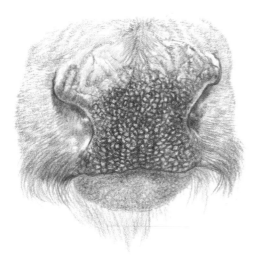

4 **Tone** Continue to build up the nose by using the 2B pencil once again, going back over the honeycomb texture of the nose to darken it further and make it more three-dimensional. Darken the inside of the nostrils and build the short lines that look like cracks on the top of his nose. Go back over the muzzle and make the longer hairs on the top lip stand out more by using the 2B pencil to work between the hairs already marked out. The 2H already on the card will repel the 2B and make it stand out darker still. Shade in the chin, making the shadow cast from the top lip darker still. There are some highlights on the edges of the nostrils that need to be kept quite light; if you have darkened them too much, use a putty eraser to lift them out again. If you have any areas that have been left white, especially at the top of the nose, gently go over them now with a 2H pencil, using this illustration as a guide.

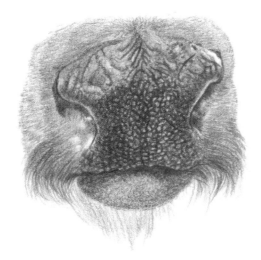

5 **Adding further depth** Carry on building up the nose with the 2B pencil – sharpen the tip if required. Use the side of the pencil tip to gently shade over the honeycomb texture of the nose where you can see more depth and shadowing on both sides around the nostrils. Be careful not to obliterate the texture there when doing so. Darken the top of the nose softly, within the cracks. Add more shading to the hairs above the nose, and to the side on the muzzle. Darken the chin area below the lip, and the long hair tufts on the top lip.

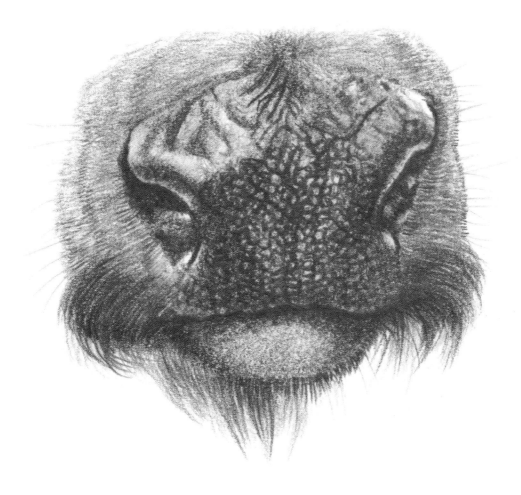

Finished nose

Select the sharpened 4B pencil and concentrate on building up the shading within the texture of the nose. Darken the chin and hairs on the muzzle, and above the nose. Now use a sharp 6B pencil to darken the inside the nostrils. As this is a high grade pencil you will find this quite grainy, so it is best to use it where you want to add soft shadowing, rather than for adding detail. Softly darken the chin and the longer tufts of hair on the bottom lip with the 6B. Go back to the 4B pencil to add any whisker detail, but use the original 2H pencil to do the whiskers on the cheeks as these don't want to be so dark that they detract from the nose. Finally, shape your putty eraser into a point to pick out any highlights in the nostrils and nose to make them stand out more.

HANDS AND FEET

There are big variables when it comes to the hands, feet, paws and hooves across the animal kingdom. The primate world has hands very similar to ours, but they have extra-long fingers to help them stay up in the trees; in contrast, when it comes to animals like moles their hands (or paws) are very uniquely designed and clawed, to help them dig underground.

We are very used to the paws of our domestic friends and could probably draw dog or cat paws quite easily from memory. However, if you were asked to sketch a crocodile foot or a gecko hand, I am sure you'd struggle to remember what they looked like without a little help! Here are a few different kinds of hands, feet, paws or hooves to show you a few examples of just how varied they can be.

Kangaroo

The kangaroo paw looks a lot like a human hand as it also has five digits; however, the palm is much shorter in relation. Since they are shaped much like human hands, they can grab, eat, groom and fight with them in a similar way. The back of the paws are covered in short, thick hair and the palms and digits are extremely padded and leathery in texture.

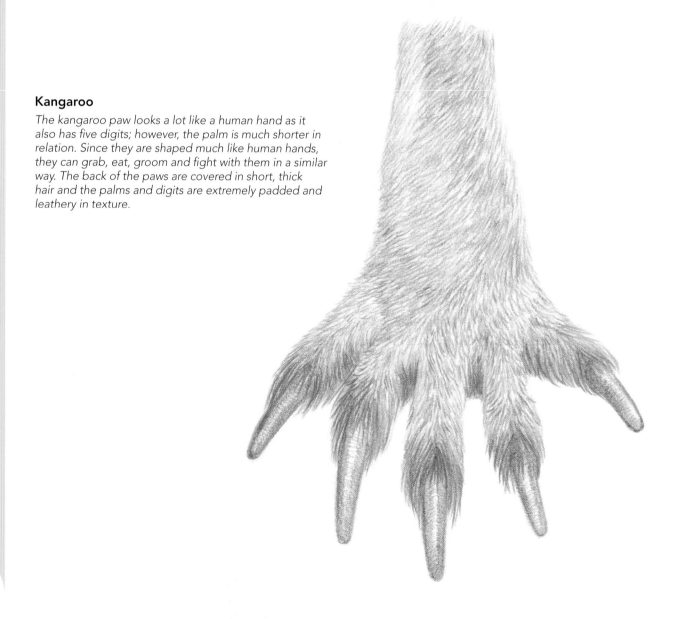

Frog

The feet of frogs are pretty interesting to look at in general, but those of a tree frog are particularly special. Tree frogs secrete a sticky mucus from the pads on their feet to help them adhere to leaves of trees, and they refresh this whenever they take a step to ensure they remain sticky. When drawing their feet, you want to make sure you create the wet look of the skin. To do this, you just need to make sure you add all the highlights and reflections from the very beginning of the drawing and keep updating them as you work, so they won't have disappeared by the time your drawing is complete.

Cat

Domestic cat paws are all much the same, with one main centre pad underneath and four smaller toe pads above it. The length and density of the fur covering the paw differs with each breed of cat, so this can make the paw look smaller or larger, but the basic biology is the same. When you are shading in the paw and adding in the fur, make sure you keep an eye on the shape and follow your reference carefully.

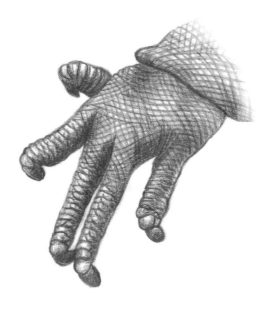

Lizard

Lizard's hands or feet can vary from species to species, but the hand of this particular lizard looks similar in shape to a human hand – albeit with bent-over finger tips and elongated nails! As there are five digits, and as one of them is similarly placed to a human thumb, a lizard's hand is quite dextrous. In terms of drawing there is quite a bit of work involved, but don't let that put you off. Just be careful that you maintain the shape of the hand while you are cross hatching or shading the textured skin. In addition, keep checking your reference photograph so that if you do go wrong, you can rectify any mistakes early on. There is nothing worse than having to rub out lots of detailed pencil work.

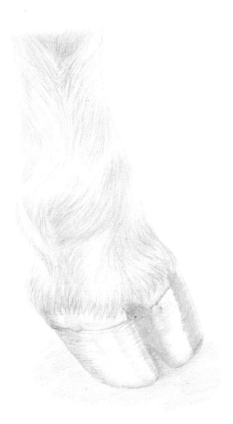

Cow

You probably didn't realize that the hoof of a cow is actually cloven, split into two toes down the middle. Farmed cows are unable to wear down their toenails naturally by walking around, so need to have their hooves trimmed annually. There should be plenty of cows out there to take your own photographs; however, to get a good image of the hoof itself (which is normally covered in grass or mud), you may wish to find a royalty-free photograph on the internet.

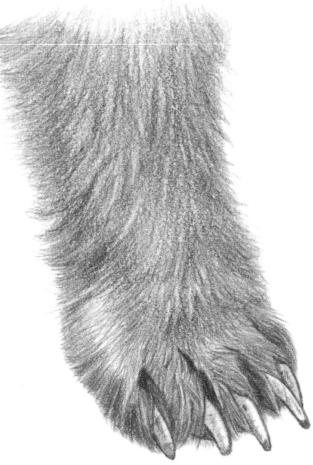

Grizzly bear

A grizzly bear's paw has five large toes, with claws that can be up to 12.75cm (5in) long and as thick as a cigar in width. A grizzly can do incredible damage with its paws and has enough power to decapitate an animal as big as a moose with simply one swipe. The paw can be bigger than a dinner plate in size, and its palm and toe pads are extremely thick and textured. In addition, grizzly bears grow a thick layer of fur on their paws and bodies overall, and the hairs are lighter at the tip than at the base. This gives the bear's fur a unique, wavy look, and is why this species namesake is 'grizzly'. When shading in the paw, use a 2H pencil first to create any areas of shine on the fur, then add the darks with a 2B pencil and finally use a 4B, to add even more depth.

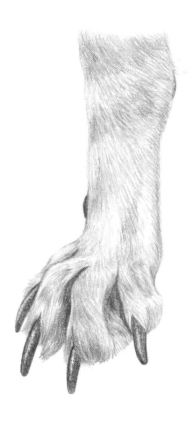

Wolf paw

Wolves have large, slightly webbed feet to prevent their feet from sinking in deep snow. To help distribute their weight better, wolves' front paws are bigger than their back paws and they have special blood vessels in their pads to prevent their core temperatures dropping when temperatures plunge. The wolf paw is very similar in shape to that of a dog, being quite compact, but a wolf has much larger claws. The example to the left is of a white wolf paw, so I started with a couple of layers of 2H pencil to establish the fur, then used a sharp 2B to add more depth. Next, the claws were shaded in with 2B and then 4B to make them very dark. Finally, I used the putty eraser to lift off some shading on the claws to create some shine.

Horse

The horse's hoof is quite large in relation to its slim ankle and, unlike a cow's, its hoof is not cloven. Be careful then when drawing the shape of the horse's leg, especially around the ankle area (known as the fetlock), as this part of the foot is very unique to horses and makes their legs easily recognizable. This particular type of hoof is from a heavier-set horse, so the leg and ankle are not as slim as an Arabian or Thoroughbred horse. The hair on the horse's leg is much shorter than the cow, and much straighter too.

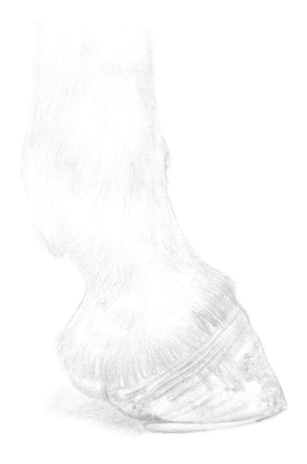

SQUIRREL HANDS

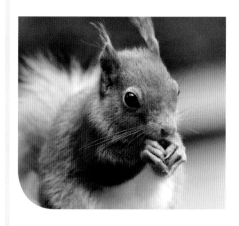

This is a picture I took of a red squirrel that I was lucky enough to have close contact with when visiting the Berkshire/ Buckinghamshire/Oxfordshire Wildlife Trust near Reading, UK. I had paid to have a photography day there a few years ago, and this little chap was just one of the animals I was lucky enough to take pictures of during my time there. Red squirrels are endangered, which is staggering considering they have been around for over for 10,000 years, since the end of the Ice Age. In the UK they can be found in Scotland, Northumberland, Wales, Northern Ireland and the Lake District in the county of Cumbria.

A squirrel's tail is used for balance but also doubles up as a fabulous furry blanket when they sleep. Their hairy ears rotate to pick up sounds, and you can witness this behaviour if you ever watch a grey squirrel in your garden: they are positively twitching all over listening for predators, ready to make a break for safety at the slightest provocation. Their hands, though a little strange to look at, are interesting to draw.

MATERIALS

Smooth white card, A4 (8¼ x 11¾in) in size: I use Clarefontaine
2H, 2B, 3B and 4B graphite pencils
Pencil sharpener
Putty eraser
Spare piece of A4 (8¼ x 11¾in) paper to rest the ball of your hand on while you work

To download and print out the full-sized photograph of the image above, please visit the web page:
www.lucyswinburne.co.uk

1 Outline Draw the basic outline using your chosen method and a 2H pencil that has a slightly worn point, to prevent any scratchy lines forming. Once you have your outline, if it is too dark you can knock back by gently using the putty eraser, which will soften any hard edges.

2 **Introducing detail and tone** Use your 2H pencil to start building up the shape of the hands very lightly. There's no need to add too much detail at this point, you just need a suggestion of shading and fur that you can follow later. Make sure you keep looking at your reference picture while you do this, to ensure you are correctly drawing the direction of the fur and the finger shapes.

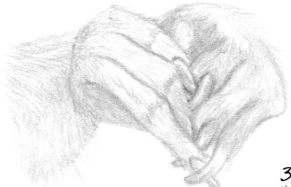

3 **Building further tone** Continue to build up the shape of the hands and the details within it, using a 2H pencil. Use a light touch, so you don't create any indented lines on the surface of the card. Double check your reference picture as you work to make sure you have the right fingers crossing over each other.

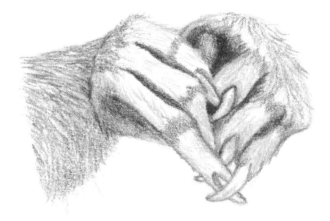

4 **Adding depth** Now use a reasonably sharp 2B pencil to begin to build up the depth of the hands overall. Don't rush this process, as it's such a small drawing and so will be difficult to erase any mistakes. Make sure you are happy with the perspective of the fingers and nails, before you make them darker with the pencil.

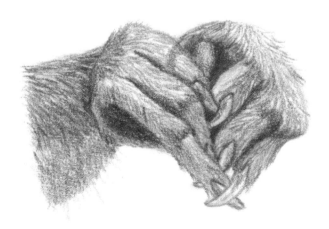

5 **Shadowing** Carry on building up the shape and shading of the hands with the 2B pencil, sharpening the tip of it if required. This is your second layer of 2B pencil, and the pressure you use can be firmer than before so that you are achieving the necessary darker tones, but not so hard as to indent the surface of the card. Don't forget to keep your hand resting on the spare paper as you work on this darker layer. Darken the nails and the shadows between the fingers, and add more depth to the fur on the arm and hands by lightly shading in the spaces between the hairs.

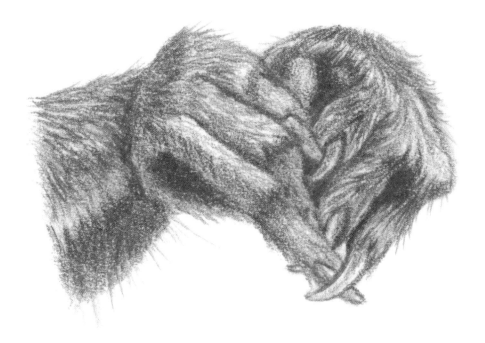

Finished hands

Sharpen your 2B again if required and start to add the final layer of shading to complete the squirrel's hands. Darken the under section of the wrist and add more depth to the overall arm too. Shade in the shadows between the fingers. Use the putty eraser to lift off some of the pencil marks in areas where there should be more light, if required. Finally, use the 2H to add a few hairs sticking up from the backs of the hands, underneath the wrist and on the outer edges of the fingers.

LEOPARD PAW

For this step by step, it's all about the technique for spots and fur. Big cats' paws are always fascinating because of the sheer size and power contained within them. Leopards are beautiful, compact, solitary and silent creatures and are often seen high up trees astride strong branches, with their legs dangling beneath them. Their paws are particularly stunning, with the spots large at the wrist joint then tapering off into smaller spots getting closer to their toes. Drawing just the paw is a good exercise to help you learn to observe fur direction and recognize how the paw shape determines the way fur lies.

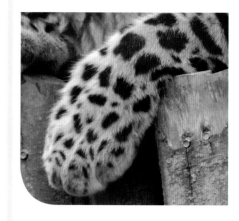

MATERIALS

Smooth white card, A4 (8¼ x 11¾in) in size: I use Clarefontaine

2H, 2B and 4B graphite pencils

Pencil sharpener

Putty eraser

Embroidery or darning needle

Spare piece of A4 (8¼ x 11¾in) paper to rest the ball of your hand on while you work

To download and print out the full-sized photograph of the image above, please visit the web page: www.lucyswinburne.co.uk

1 Outline Draw the basic outline using your chosen method and a 2H pencil. Keep the pressure very light with the pencil to prevent making indentations in the paper; the outline needs to be just dark enough for you to see. Do the same for the spots to create a 'guide' that you will be able to follow as you draw in the subsequent layers later in this drawing. To help you capture the pale hairs that fall over the spots, use the embroidery or darning needle to indent the card deliberately, carefully flicking the needle over the surface of the card to make short, indented lines. You must start at the root of the hair and then flick the needle out towards the end, so the root is thicker than the tip. When you shade, these indented lines will start to show up white on the spots. Be careful not to tear the surface of the card with the needle when you do this, and only add a few to the spots you feel would benefit.

2 **Introducing detail** Continuing with the 2H pencil, begin to create the fur. Remember to work very lightly, as this is just the first layer of pencil and you don't want to fill the surface of the paw with too much detail before adding darker grade pencils later on. For now, flick your pencil over the edges of the spots so that they are integrated with the rest of the drawing, but again don't fill them in completely or you will lose the sense of where they are within the sketch – this is important, to ensure you shade and highlight them correctly later on. Work down the paw until it is covered with a light layer of fur, taking care that you regularly check your reference image as you work to analyze fur direction and its length.

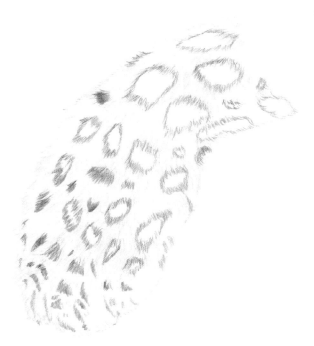

3 **Building on the details** Use a reasonably sharp 2B pencil to outline the larger spots in the paw, so that they are easily recognizable within the fur. You can fill in the smaller ones with the 2B pencil, using short, gentle strokes. Don't forget to rest your hand on the spare piece of paper to prevent smudging as you work.

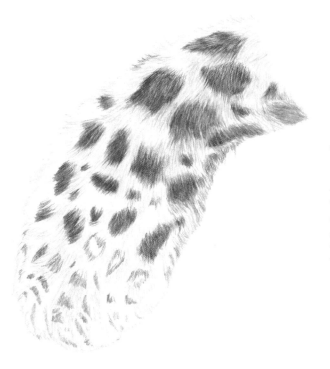

4 **Adding texture** Go back over the main paw with another layer of 2H pencil, to make the fur between the spots a bit darker and more defined. Then, return to the 2B pencil and start to fill in the spots, gently building them up until they get darker. To create lighter, wispy hairs that look as if they are sticking out over the spots, work backwards with the pencil, up into the hair above the spots and splitting them up with your 2B pencil. You will notice that the indented lines are starting to stand out more, the darker you make the spots.

5 **Tone** Now sharpen the 4B pencil and go back over all of the spots to make them very dark. Keep working backwards with the pencil into the hair above and below the spots, to further define the pale, indented hairs that hang over the spots. Use the 2H where required to add more depth to the light fur too.

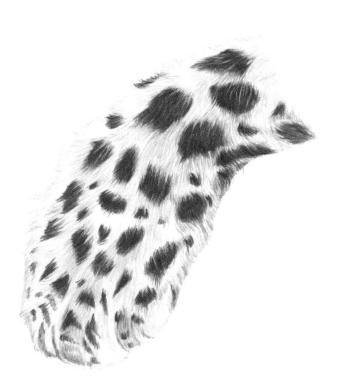

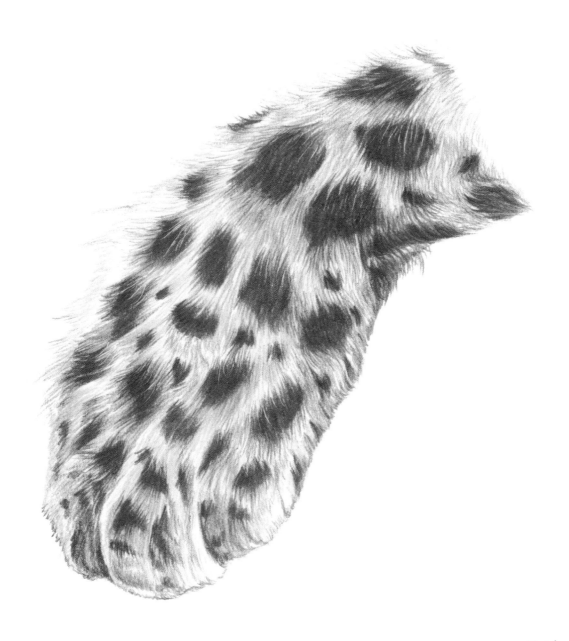

Finished paw

Sharpen the 2B pencil and work your way back over the main, pale fur between the spots where required to darken it and give the paw its shape, based on your reference picture. Continue to rest your hand on your rough paper while you do this, do prevent smudging. To complete the foot, use the 2B pencil to drag the spots into the paler fur, to make them appear as if they are coming out of the light fur rather than just lying on top. Finally, clean the background up with your putty eraser where necessary.

TEXTURE AND PATTERN

Just as there are many different types of animals in the world, there are just as many different textures and patterns associated with them. From the beautifully coloured scales of lizards or reptiles right through to the camouflaged fur of big cats, an animal's skin or coat is very unique.

Elephants and rhinos have similar skin in that the texture is very detailed, full of tiny crevices and wrinkled here and there to help keep the animals cool in hot weather. Drawing one of these creatures is no mean feat, but once successfully achieved is a very satisfying accomplishment. Big cat fur patterns vary greatly but once you have mastered stripes or spots, you can pretty much tackle any one of them with confidence.

Even when you've successfully drawn the coat or skin of your animals, it's worth considering other factors that may alter its appearance: fur itself has a very different look when it is wet, as it goes stiff and spiky due to its waterproof qualities; and a wet reptile will look glossy and sleek, with water droplets standing proud of its skin.

Here are a few examples of textures and pattern to get you thinking about the different ways to tackle drawing them.

Wolf fur

A wolf's fur is made up of two layers. There is the outer layer, which is made of coarse, long hairs known as 'guard hairs', and this layer is water and snow repellent. It also contains the colour pigments that lend the wolf its characteristic colour and patterning. The inner layer, or underfur, is soft and thick, almost wool-like, and this thick fur serves to trap air in and help insulate the wolf from the cold. Wolf fur, much like dog fur, becomes very separated and spiky when wet (shown here), compared to its fine and flat appearance when dry. When drawing wet fur, you need to create pointed, almost dart-shaped areas of hair; shading is then added underneath each dart to show that it is standing proud of the body.

Tortoise shell

A tortoise shell is immediately recognizable, with its swirled, repetitive patterning and raised bony sections known as 'scutes'. When attempting to draw the shell, you need to study the shapes carefully, mapping out each section in light pencil initially, counting the 'shell' patterns as you do this so that you don't get lost and draw more than required. Here, I started off with a 2H pencil to draw the outline of the shell; then, when I was sure the drawing was correct, I started to add more depth with a sharp 2B pencil, which brought the drawing to life.

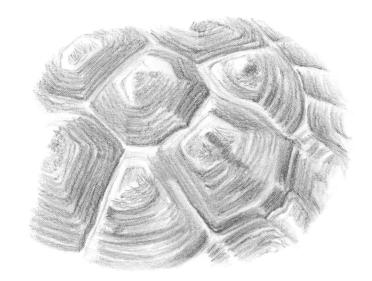

Elephant eyelid

Another easily recognizable feature: an elephant's eye and eyelid. Elephants have incredibly long eyelashes that can reach well past their eyes and onto their cheeks. The area around the eye is extremely textured, with deep grooves and crevasses. To create this texture, you need to start with a light pencilled outline, to map out the key shapes and details. When you are happy with your basic drawing, use a sharp 2B pencil to shade in the main surface of the skin, and the deep lines and furrows within it. If you need to add even more depth, use a sharp 4B to darken sections of the drawing further where required.

African wild dog fur

This drawn section of fur on an African wild dog was taken from an area on the base of its tail. Wild dog coats are great to study as their fur is extremely striking and unusual, an adaptation that camouflages them effectively in their habitat. Use a 2H pencil to sketch the fur detail and then continue with this pencil to add the first layer of shading all over. Next, take a sharp 2B pencil and darken the fur either side of the white sections, but as you do this drag short pencil strokes into the white areas, to blend the two sections together a little. To darken the fur even more, use a sharp 4B and go over the hairs once again. A putty eraser can lift off excess pencil in areas where you want to create highlights or to lighten the white areas if they are too grey.

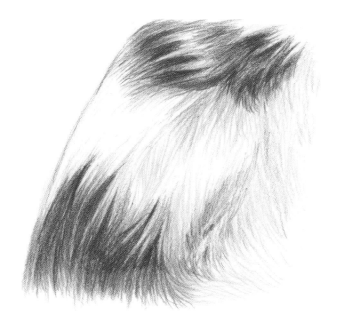

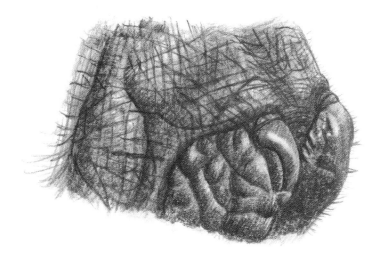

Hippo nose

A hippo, or hippopotamus (which comes from the Ancient Greek, meaning 'river horse') spends most of its life submerged in water; but, amazingly, they can't swim. Their typical, yawning, open-mouthed pose is actually a warning that you are invading their territory – not a sign of being tired! You probably haven't had the opportunity to study their noses in profile up close before, but they are extremely textured and covered in lots of short, spiky whiskers. To build up the texture, it is best to start by sketching out the basic outline of the area you are drawing with a 2H pencil and add all of the pattern and texture lightly early on. You can then build on this through several layers, using 2B and 4B pencils. Again, use your putty eraser at the end to lift off some of the pencil shading to add some highlights.

Hog snout

This is the nose of a red river hog, also known as a bush pig, found in the forests of central and western Africa. These hogs have a strong and powerful snout that's used to dig up roots, their main source of food. Generally, they survive on vegetation but will quite happily snack on insects, bird eggs and small mammals in the meantime if they get the opportunity. As with the other examples in this section, it is recommended that you sketch the outline of the subject first with the 2H, then start to add more detail with the same pencil. When you have gone as dark as you can go with the 2H, sharpen a 2B pencil and darken further where required.

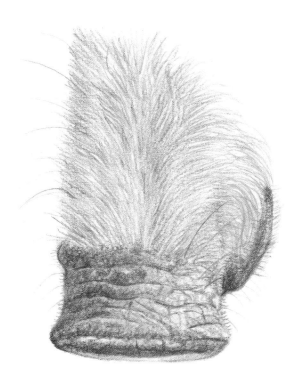

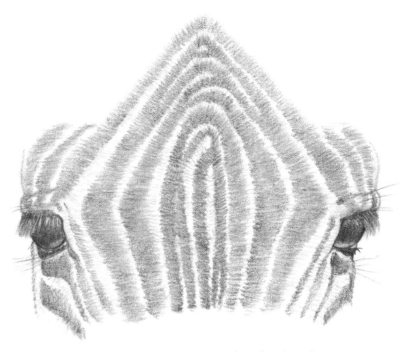

Zebra forehead

The zebra is instantly recognizable thanks to its stripy black and white coat. These markings are unique to each individual zebra; one explanation for this is, with females being the sole caretakers of their foals, it is very important that baby zebras learn to recognize their mother. Mum will keep other adult female zebras away from her baby for a few days after it is born, to ensure that her young one learns her smell, stripe pattern and voice. Completing a drawing of a zebra is a big challenge as you can get lost very easily when mapping out the stripes. Make it as easy as possible by sketching out the key shapes first with a 2H pencil while continually referring to the original photo. If you wish, you could even trace from the reference image, just to give yourself a head start. When you have all the key details in, and are happy with the shape of the forehead and eyes, add shading to your drawing with a 2B pencil.

Fox eye and cheek

Foxes are beautiful to look at, with their stunning rich red coat and full, bushy tail. A fox's eyes are particularly attractive with their deep liquid amber colouring and crisp black outlines. Their eyes are perfectly positioned midway on their head between their ears and nose. The fur direction around the eye, eyebrow and cheek is the same as your pet dog, so if you need extra detail to help you draw your sketch and you have a dog available, why not use your live model? Start with a basic outline as before, with your 2H pencil, and then build up one layer of shading at a time using the same pencil. Note that the hairs in the corner of the eye, near the nose, are tiny compared to the hairs under and over the eye; for these, switch to a 2B pencil then go back over the layers worked with the 2H pencil, to suitably darken the hairs there. Finally, go back over the eye area with a 4B pencil to add even more depth.

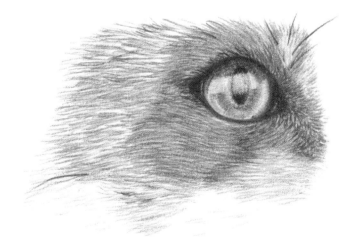

TEXTURE: SNAKE

A snake might seem like an odd choice for this step by step, especially when we usually focus on soft, textured fur, but it's always good to challenge yourself and try something new. There's a lot of uniformity in the cells that make up a snake's skin, and learning how to build up the texture while creating a 3D image can be interesting.

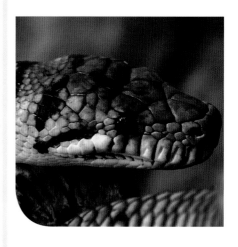

MATERIALS

Smooth white card, A4 (8¼ x 11¾in) in size: I use Clarefontaine

2H, 2B and 4B graphite pencils

Pencil sharpener

Putty eraser

Spare piece of A4 (8¼ x 11¾in) paper, to rest the ball of your hand on while you work

To download and print out the full-sized photograph of the image above, please visit the web page:
www.lucyswinburne.co.uk

1 Outline Using a 2H pencil with a slightly worn point and whichever method suits you best, draw the main outline of the snake. As snake skin is very detailed and you could easily lose where you are when you begin working, I recommend sketching out where the markings are, so that you have a basic map to follow when you begin capturing details. When the outline is complete, knock it back gently with a putty eraser to soften any hard edges and take away some of the strength of your pencil lines if they are too dark.

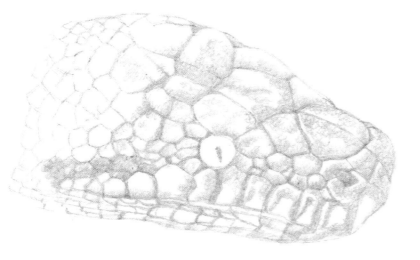

2　**Introducing texture and tone** Use your spare piece of A4 paper to rest your hand on as you work to protect the rest of the card from getting marked. Begin to shade in the cells on the snake's head with the 2H pencil, darkening the outline of the cells gently with the worn, soft edge of the pencil. I like to start with the area around the eye, but it is personal choice where you would like to begin. If you feel any scratching, use some rough paper to find the soft edge again before you continue. Begin shading in the texture on the cells by using a circular, scribble-like motion; do this very lightly as you will be darkening this texture later with a darker grade of pencil. Continue to work across the head in this way, regularly checking your reference image for further details.

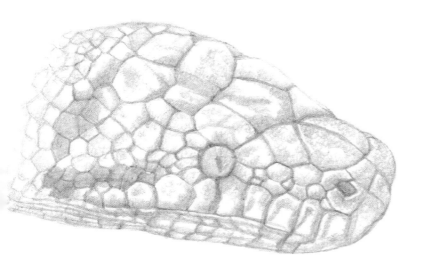

3　**Adding depth** Using the same pencil, darken the cells on the side of the head, and those towards the back where they look black. You won't get the depth you require with this pencil, but it provides a basecoat for the next grade of pencil. Continue to build up the texture over the whole head, starting with gentle general shading and then going back around each cell to darken the outlines of them, so they are beginning to stand proud. Add the first layer of pencil to the eye, shading from the outer edge then working towards the centre. This helps to create a three-dimensional look to the eye.

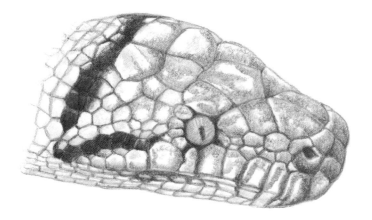

4 **Building tone** Now select the 2B pencil and begin to draw over the outlines of the cells again so they stand out even further – don't forget to keep your hand resting on the spare piece of paper. Then, use the soft edge of the pencil to begin to darken the textures and patterns within the cells on the snake's head. Darken the inside of the nostril, taking care to leave a highlight around the edge where the light is catching it. Go back over the eye again and the pupil too, again leaving the highlights unshaded at the top of the eye. Shade in the darkest black cells at the sides and towards the back of the snake's head with a couple of layers of 2B; these will act as a nice contrast to the other dark areas on the snake's head.

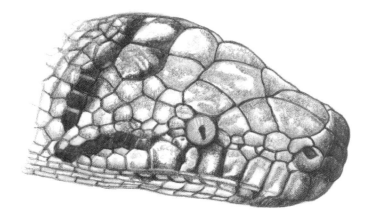

5 **Adding further texture and depth** Sharpen the 2B and go back over the outlines of the cells to make sure they are really crisp and stand out. It will take a couple more layers of 2B to build up the other cells and their texture, so take your time and don't press the pencil too hard. Go over all of the details again if you feel they need to be more refined. Add more depth and shading across the whole of the skin area where you think it is required. Go back over the eye, but don't overwork it just yet: we will use another pencil in a darker grade in the final stage, to darken everything further and complete any remaining details.

Finished snake skin

Select a reasonably sharp 4B pencil now and concentrate on building up the depth overall to darken areas across the snake's skin for the last time. Take care to check your darker shaded sections of skin against the very black cells on the side and the back of the head, to prevent your shaded cells competing with the latter. Darken the nostril and the eye again, going over the eye a couple of times very softly – don't press hard or you'll end up with a lot of shine. Shape the putty eraser into a point and lift out some highlights in the eye so that the pupil can be seen. Use the 2H and 2B pencils again to add any light shading to areas you may have missed, and to tidy up the outline to complete the snake's head. Finally, use the putty eraser to clean away any pencil smudges or marks on the background.

PATTERN:
SCOTTISH WILDCAT

For this step by step featuring patterns, I thought it might be fun to replicate the M-shaped markings on the forehead of the animal we are most familiar with – the cat. This picture is of a Scottish wildcat, but in fact the same markings appear on the domestic tabby cats that we know and love.

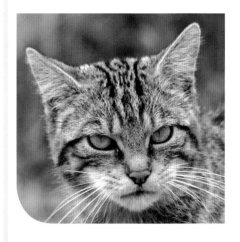

MATERIALS

Smooth white card, A4 (8¼ x 11¾in) in size: I use Clarefontaine

2H, 2B, 3B and 6B graphite pencils

Pencil sharpener

Putty eraser

Spare piece of A4 (8¼ x 11¾in) paper, to rest the ball of your hand on while you work

To download and print out the full-sized photograph of the image above, please visit the web page: www.lucyswinburne.co.uk

1 Outline Using an unsharpened 2H pencil and whichever method suits you best, draw the basic outline of the top of the cat's head. At this stage you need only a simple outline of where the markings appear to give you a guide as to where you can begin shading. I have included the edges of the ears, to give some perspective and proportion to the drawing. Use the spare piece of paper to rest your hand on as you work to prevent smudging.

2 **Introducing detail and texture** Continue to use the 2H pencil to build up the hairs on the cat's head. Remember to keep checking your reference image to ensure the fur is the correct length. For instance, the hairs on the top of the head and forehead are longer than the short hairs on the ears.

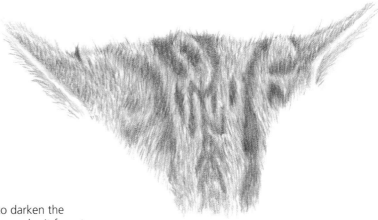

3 **Adding depth** Now sharpen a 2B pencil and begin to darken the darkest markings you can observe on the cat first, so that you don't forget where they are. Then, use the same pencil gently to darken the hairs in between these darkest areas of the pattern, flicking the hairs towards the dark patches as you go. As you don't want to end up with areas of dark pencil that stand out on their own, you need to blend them in now; you can then build on these features as you continue to work.

4 **Building tone** Select a sharp 3B pencil and begin to work back over the darkest markings exactly as before in Step 3. Don't forget to keep resting your hand on your spare piece of paper to prevent smudging, especially as you are now using a heavier grade pencil. Look for the dark hairs that also appear within the lighter areas too, and lightly shade these in.

5 **Shadowing** Now select a sharp 6B pencil – the last grade of pencil you will need to complete this step by step. Be aware that this pencil sheds excess graphite fragments, so you will need to remove any particles by blowing your work now and then or lifting them off with a putty eraser. If you don't, these particles could stick to your surface if they become squashed or smudged, and these are hard to remove. With the 6B, carefully build up the darkest markings. A couple of layers should be all you need. The illustration shows the 6B added only to the left side of the picture up to the centre of the crown, so that you can see the difference it will make to your drawing. You can also sharpen your 3B and go back over to add more detail at this stage if required. Use your putty eraser to lift off any pencil marks that are too dark, especially if the section is meant to have a light area of fur.

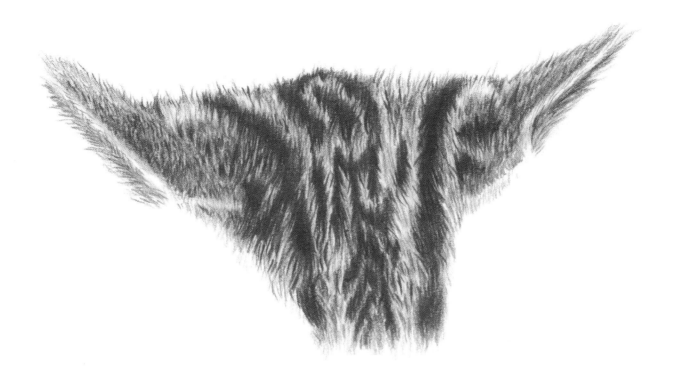

Finished Scottish wildcat fur pattern

Continue all over the cat's head, adding more 6B to the darker areas and only suggestions of the 6B pencil in the lighter sections, to help link the light and dark areas. Keep the pencil tip sharp throughout. Finally, when you are happy that the 'M' shape is featuring well on the forehead, sharpen your 3B and flick out some fine, dark hairs on the top of the head, at the back, to finish.

WILD ANIMALS
WOLF

The wolf is my favourite animal, as anyone who knows me will be well aware! No dog lover can help but be moved by their grace and beauty. A much maligned and misunderstood species, wolves are shy, retiring and hard to find. Thankfully there are many people who have dedicated their lives to studying this amazing pack animal, and after many years of persecuting them, we are finally beginning to give wolves the respect they deserve.

The model for this project is a wolf called Tatra, one of two sister wolves at Paradise Park in Hertfordshire, UK. This is a photograph of her in full winter coat, when she looks her most stunning.

MATERIALS

Smooth white card, 42 x 30cm (16½ x 11¾in): I use Clarefontaine
2H, HB, 2B and 6B graphite pencils
3B graphite stick
Pencil sharpener
Putty eraser
Embroidery or darning needle
Spare piece of A4 (8¼ x 11¾in) paper, to rest the ball of your hand on while you work

To download and print out the full-sized photograph of the image below, please visit the web page: www.lucyswinburne.co.uk

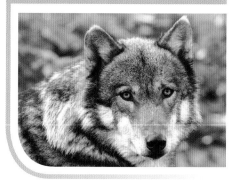

1 Outline Create a grid on your card using a 2H pencil very softly so you can erase the grid lines easily when you no longer need them (see pages 23–24 for more information), and transfer the outline to the card.

Indenting hairs To ensure you are left with white hairs on your wolf (for instance her lips, ears and cheek fur), use an embroidery needle to score the short or long hairs onto your outline, starting from the root and working outwards to the tip. Even though these are mainly short strokes it is a good idea to practise first on some spare card so that you are fairly confident before you start. When you first shade over this area, use a soft 2B pencil to shade across the indented area, being careful not to let the pencil point fall into the scored lines as removing this will be hard. Your indented whiskers will now stand out from your background as you work.

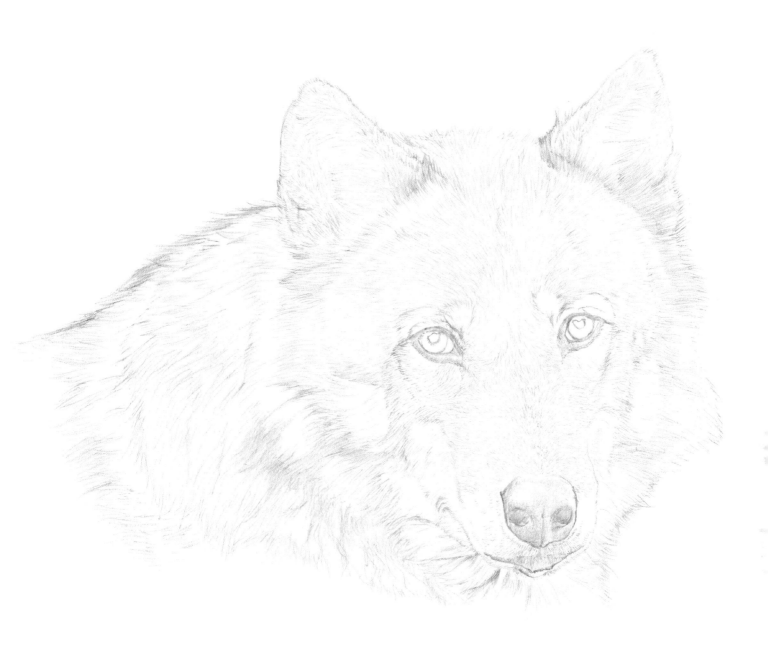

2 Fur and features Where to start is a personal choice but the eye area is generally good as the hair direction is very obvious. Use a sharp 2H pencil to add the first layer of fur to the wolf's coat. Take time to emulate the fur direction as it needs to be correct to show off her bone structure to full effect. Gently fill in the bottom eyelid and dark inner eye (around the iris) and the nose. For the nose use a blunt point and shade in small circular movements to create texture.

TIP

As the background is to remain white, throughout the drawing rest the side of your hand on a piece of rough paper to prevent smudging. Use your putty eraser to keep the background clean as you work.

3 **Developing the fur and features** Continue to build up the wolf's coat with a sharp 2H pencil, noting how the fur length changes from short to long when you move away from the face. Keep your strokes very short and crisp on the muzzle in particular. Darken the fur at the base of the ears and inside, keeping the pressure light on the pencil. After a few layers of pencil, it will gradually begin to darken. Softly add another couple of layers of 2H to the nose. Add a very light layer of 2H to the pupils, iris and inner eye on both eyes. Leave the highlights in the pupils untouched. Ensure the pupils have a rough, not hard, edge to them.

TIP

Do not be tempted to press harder to achieve a darker tone, you will only end up with a shine. Repeated soft layers are the only way to build on depth using this technique.

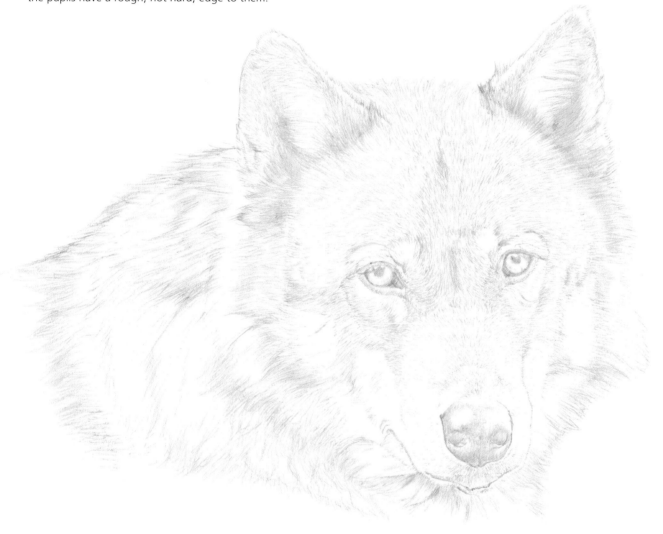

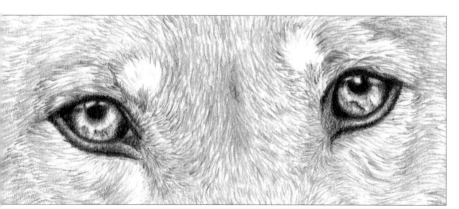

4 **Eyes** Sharpen a 2B graphite pencil and darken the eyes further, taking care not to press too hard. Light touches can be erased if necessary, but too much pressure makes it almost impossible. Keep the pencil sharp so details stay crisp. Note how the eyes are made up of tiny lines and are not simply solid tones. Gradually build on the depth of the pupils and the eyelids. Sharpen a 3B graphite stick and build on the dark areas further, finally using a 6B very softly to make the black as dark as possible. These dark areas will be a guide to how dark the coat will need to be at the end.

5 **Nose** With the 2B pencil, top up the darks on the nose, again using small circular movements to fill it in. Gently shade over the highlighted areas on the nose to blend them in, as these need to be light grey not white. Next use the 6B pencil to darken the nose further, beginning at the base and working up past the nostrils and towards the top. Make sure the inside of the nostrils are as dark as they can be.

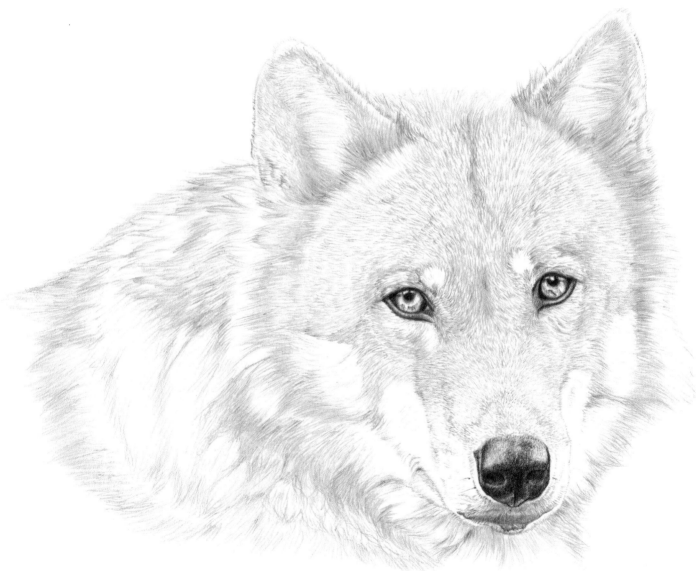

6 **Darkening the fur** Sharpen an HB pencil and go back over the coat again, darkening the fur in all areas worked on previously. Keep the hairs very short, almost dot-like as you get really close to the nose. As before, keep the pencil pressure firm but not hard. As you work continue to monitor how close the tone of the coat is in comparison to the darks of the eyes and nose. It is a long process to build the darks but will be well worth the effort.

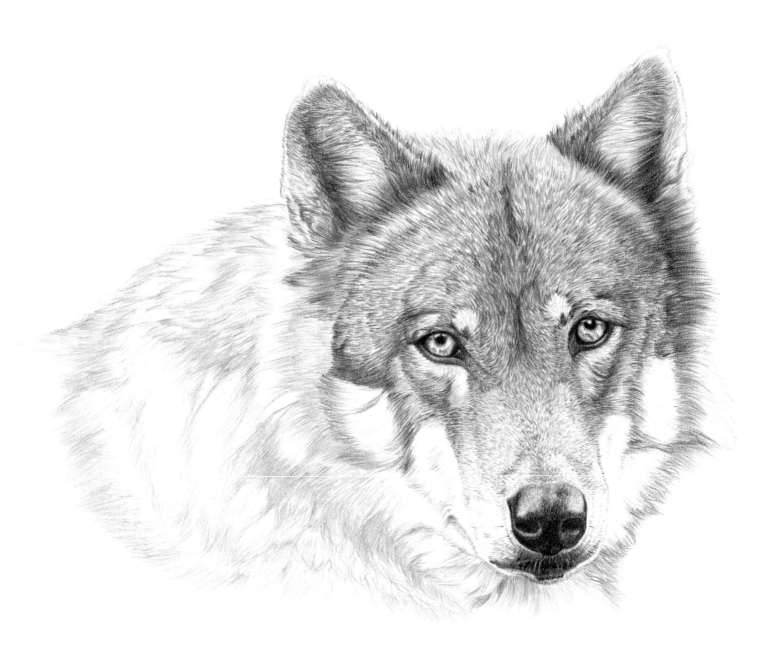

7 Tone Now you can sharpen a 6B pencil and use it to really make a difference to the tonal value of the wolf's coat. This pencil will wear down quite quickly and lose its point, so sharpen it regularly to maintain the crisp lines of the hairs and fur. There is no need to use a middle grade pencil as there is a significant amount of pencil already laid down, and a limit to the amount of graphite the smooth card will take. Begin around the eyes and work up towards the ears. The picture above shows what a big difference adding 6B to the head has made – compare it with the unworked neck fur.

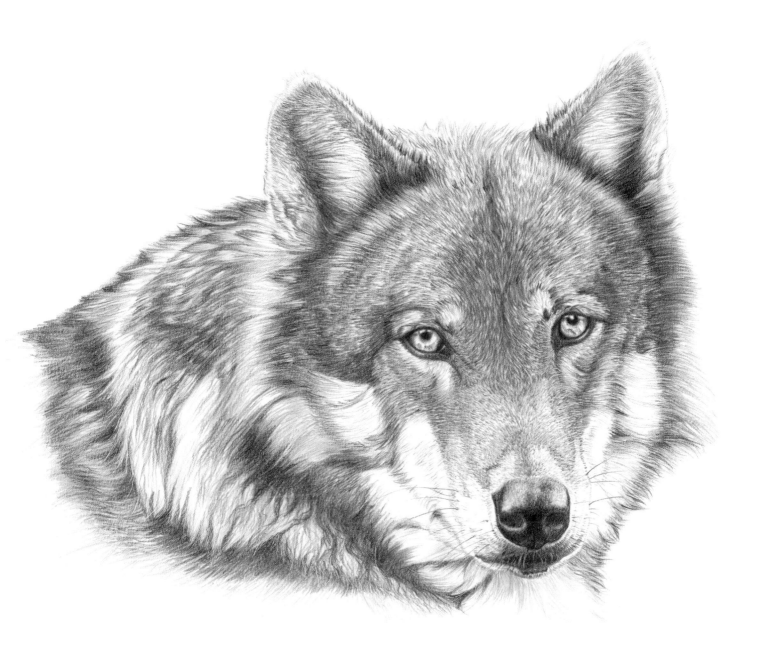

A Portrait of Tatra

42 x 30cm (16½ x 11¾in)
Graphite pencil on smooth white card.

At the final stage, continue to work around the wolf until you have at least one layer of 6B all over. If the darkest area of fur is still not as dark as the nose, add another layer of 6B, keeping the pencil sharp. When this is done, shade over any fur that is not white with the 2H pencil gently, darken the eyes and nose further if required with the 6B pencil and then concentrate on the neck area. Make sure you take time to make the fur on the side of the neck stand out too. Finally, touch up the pupils with 6B, add some whiskers to the muzzle with a sharp 3B, whiten up any highlights with your putty eraser and then sit back and enjoy your artwork!

MEERKAT

The meerkat is a very popular little animal. Irresistibly inquisitive and endearing, they have gained in popularity over the last few years. People are drawn to them for obvious reasons and we are comforted by how they care and look out for one another. Although surprisingly small in real life, meerkats are endlessly intriguing. It becomes very apparent when you see their diminutive size that surviving is quite a tall order in their habitat and then the reason for their pack protection behaviour becomes clear.

1 Outline Draw the outline using your chosen method of grid, tracing or freehand. This outline is drawn on 30 x 42cm (11¾ x 16½in) smooth white card, with the drawing itself roughly 21 x 30cm (8¼ x 11¾in) in the centre of the card. The size given is the smallest I recommend you draw, as any smaller will make the meerkat difficult to work on and to showcase the detail.

MATERIALS

Smooth white card, 30 x 42cm (11¾ x 16½in): I use Clarefontaine
2H, B, 3B and 6B graphite pencils
Pencil sharpener
Putty eraser
Embroidery or darning needle
Spare piece of A4 (8¼ x 11¾in) paper, to rest the ball of your hand on while you work

To download and print out the full-sized photograph of the image below, please visit the web page: www.lucyswinburne.co.uk

TIP

Do not forget to have a piece of rough paper ready to rest your hand on as you work to prevent smudging.

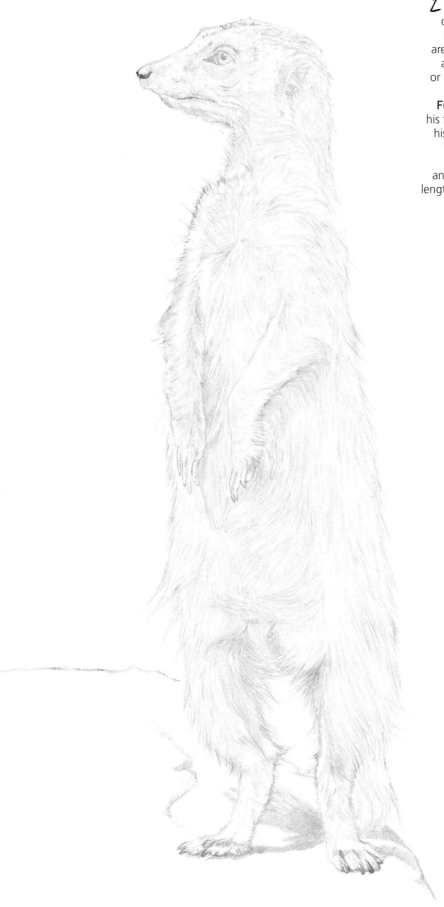

2 **Indenting** Indent any light hairs that cross over in front of a dark background as you will not be able to add these in afterwards. There are some on his arms, his mouth and chin, neck and the insides of his legs. Use an embroidery or darning needle as these have a thick, not too sharp point to indent these hairs on the card.

Fur Use a sharp 2H pencil to give the meerkat his first layer of fur. Try to leave the highlights on his coat almost untouched by using a very light, fine layer of pencil. Build the fur up gradually, starting with the very short hairs on his head and face. As you move down his body the hairs lengthen gradually. When you get to his feet, add some detail and create the beginnings of the shadow behind him on the rock.

3 Rock texture Sharpen the 2H pencil again and use it to fill in the rock beneath the meerkat. Work from the front of the rock backwards, using a small scribble technique which will give the rock a texture that you can build on. Keep the rear of the rock light, as this section is receding into the distance. Add a couple of layers of 2H pencil to the rock and top up the shadow to make it darker too. Sharpen a B pencil and begin to add the next layer of depth to the meerkat working from the head down.

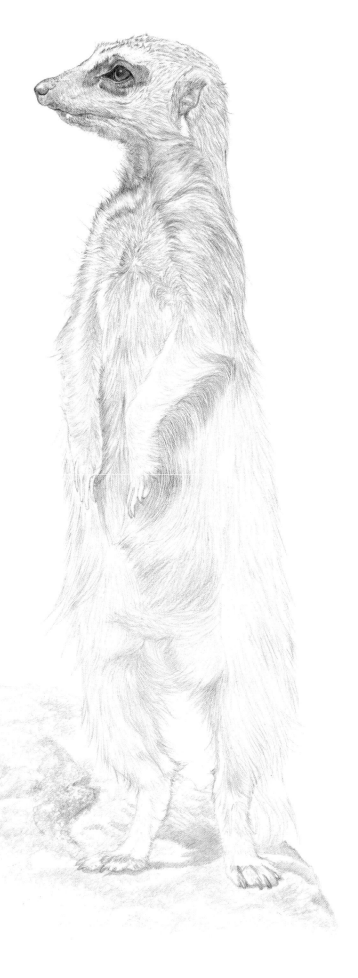

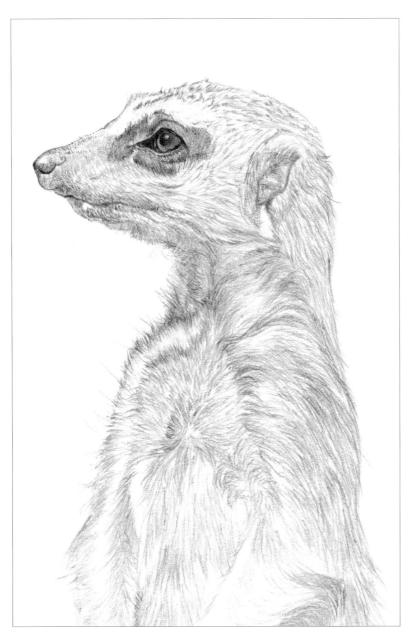

4 **Tone** Continue to add the B pencil. The marks made by your pencil at this stage have to be very delicate and crisp to create the fur effect. Going too dark too early will not create the texture you are trying to achieve. Work carefully around the highlights so as not to lose them. If you need to make them more apparent, shape your putty eraser and press it onto the area to lift off some pencil. Work slowly, regularly checking your reference picture and continuing to lean on your rough paper to protect your white background. Keep the pencil tip sharp.

Features Add some more 2H to the iris before darkening further with the B pencil to fill in the pupil softly. Next use the B pencil to create the dark shadow over the top of the iris (cast by the brow) and fill in the inner eye. Darken the nose and mouth line, and the shadow under the chin and on the neck.

5 Adding depth Continue to add more depth over the meerkat's coat using the same B pencil. Darken the rock from the front and begin to fade it out once you go past the middle section towards the back. Darken the shadow by the meerkat's feet. Using the sharp B pencil add another layer on the meerkat. When you can see that the B pencil is no longer darkening and it starts to feel as though it is becoming slightly resistant to the card's surface, sharpen a 3B pencil and go back over the coat again from head to toe. Again, use the putty eraser to extend or replace any lost highlights as you work.

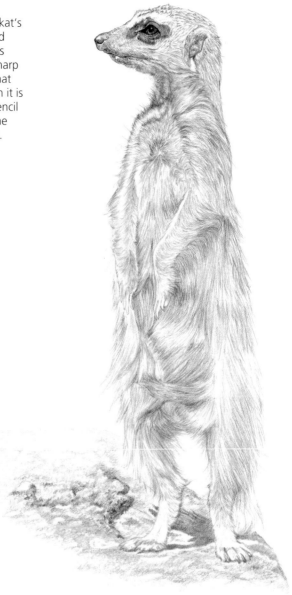

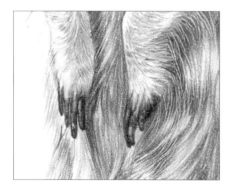
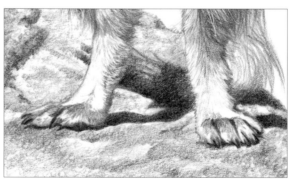

6 Shadows Continue by darkening all the shadows on the coat using the 3B, especially those cast by the backs of his arms onto his body. Add more depth to all the darker fur as this will serve to make the highlights stand out even more.

Details Create further texture on the rock and darken the shadow behind the meerkat. Pick out the detail with the 3B pencil on his fingers, feet and nails and darken where appropriate (see the close-ups above for details). Your pencil tip must be sharp at all times as you complete these sections.

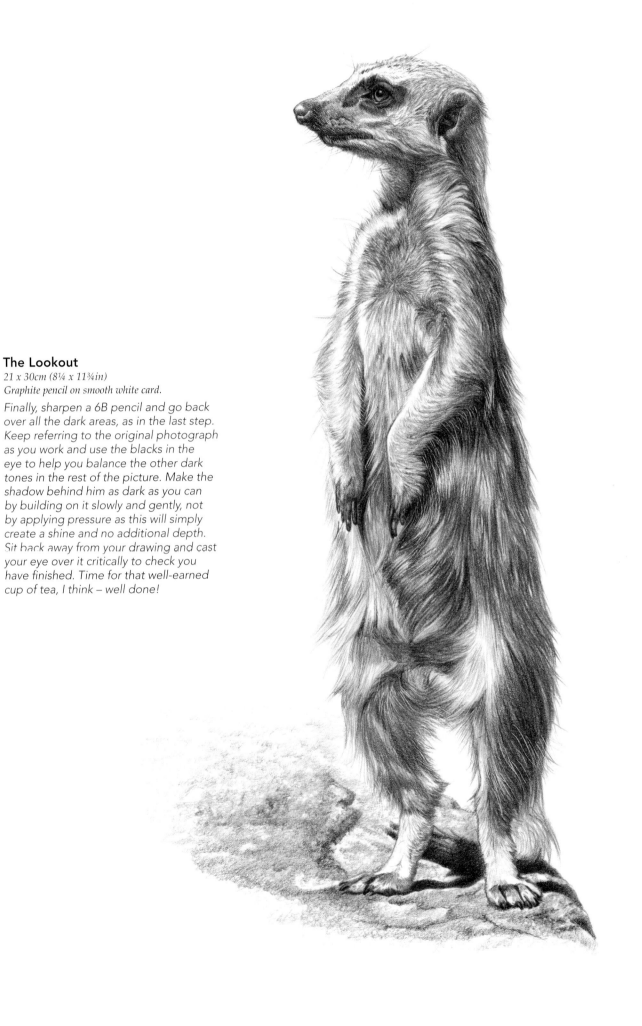

The Lookout

21 x 30cm (8¼ x 11¾in)
Graphite pencil on smooth white card.

Finally, sharpen a 6B pencil and go back over all the dark areas, as in the last step. Keep referring to the original photograph as you work and use the blacks in the eye to help you balance the other dark tones in the rest of the picture. Make the shadow behind him as dark as you can by building on it slowly and gently, not by applying pressure as this will simply create a shine and no additional depth. Sit back away from your drawing and cast your eye over it critically to check you have finished. Time for that well-earned cup of tea, I think – well done!

RED PANDA

For this step by step I thought it would be fun to draw a Red Panda. Whatever zoo or wildlife park I have been to, these creatures have been the most difficult to see and photograph – they never stop eating or moving; either that, or they are so high up in the trees that you can't see them at all! Personally, I think they are one of the prettiest and sweetest animals to study, so I was really happy to discover this beautiful reference picture of one to work from.

MATERIALS

Smooth white card, A4 (8¼ x 11¾in) in size: I use Clarefontaine 2H, 2B, 4B and 6B graphite pencils
Pencil sharpener
Putty eraser
Embroidery or darning needle
Spare piece of A4 (8¼ x 11¾in) paper, to rest the ball of your hand on while you work

To download and print out the full-sized photograph of the image below, please visit the web page: www.lucyswinburne.co.uk

1 Outline Draw the basic outline using your chosen method of grid, tracing or freehand. To begin, you just need the main features drawn in very lightly. Your outline should not need to be darker than the below image; if it is, when you have completed your outline, use a putty eraser to pick off some of the dark pencil lines if it is too dark, and soften any hard edges.

2 Indenting First you need to create the white whiskers by embossing the card with a sharp tool – here, I am using the tip of an embroidery or darning needle. Holding your needle at an angle, start at the root of one of the white whiskers on the muzzle of the panda and flick outwards. Don't overdo the whiskers. Practise on a similar piece of card first before working on your actual drawing. You won't see them to begin with, but the indentations you create will slowly emerge later when you shade over them with high grade pencils, appearing as white lines.

Fur Next, use your 2H pencil to add the first layer of orange fur on the panda. Make sure you rest your hand on your rough paper before you begin, to prevent smudging the drawing. There is no need to press the pencil harder to try to make the fur darker, as this won't work with this light grade pencil. You will be using heavier grades of pencils later to create the gradients of orange within his coat. For now, just one layer of this pencil for the fur will do. Apart from a few pencil marks in the centre of the ears to begin suggesting tone, leave the white areas on the panda's face untouched for now. The fur that is slightly out of focus on his back can be filled in with the flat, worn side of the 2H pencil, so that you create soft, detail-free layer of pencil markings to suggest its distance from the viewer. Create the hairs on the paw but again, don't shade the black area between the paw and orange back of the panda; you'll use a dark pencil for this later. Start to add some texture to the rock face in the foreground.

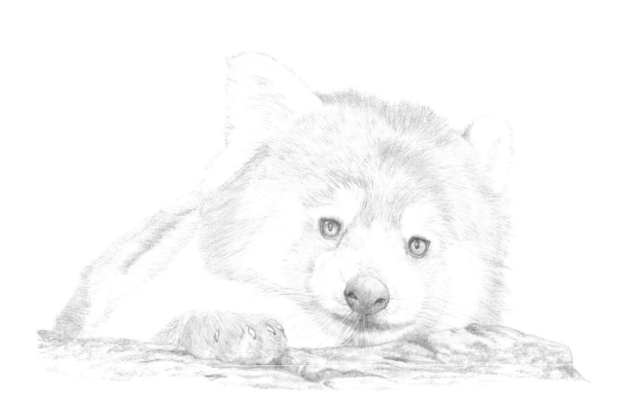

3 **Developing fur and features** Continue to build on the details with the 2H pencil. Add a soft layer or two of pencil to the inside of the iris within both eyes and fill in the pupil almost entirely, leaving a light area in the centre as highlights. Create some texture on the nose by using the blunt edge of the lead and working the pencil all over using small, circular movements. Fill in the nostrils, pressing down on the pencil a little harder this time to make them darker than the outside of the nose. Gently darken the mouth area and the paw on the rock.

Darkening Add some more depth to the rock face that the panda is resting on. Go back over the darker orange fur at the very top of the head a couple of times to add more depth, working gently with the pencil, and do this across the forehead too. Darken where required on the panda's back.

Details Add a little detail by creating the fine, short dark hairs on his white muzzle, near the eyes, above the nose and near the mouth.

4 **Tone** While resting your hand on your rough paper, use a sharp 2B pencil to build up the eyes including the iris, pupils and the outline. Next, go back over the nose using the same method as before, building up with a couple of layers. Keep the pencil light where you can see highlights. You can always make the highlights stand out more by using the putty eraser to pick off excess pencil in those areas.

Adding more depth Continue to work around the panda's head, adding more depth to the overall fur and darkening the deep orange areas, so they are quite dark under his eyes and on the side of his head. As you shade the dark bands of fur under his eyes and round his muzzle, take care not to let your pencil tip fall into your indentations and fill them up. You should start to see them stand out white as you work. It will require at least a couple of layers of 2B in these areas to get the fur dark enough. Carefully add some dark hair in the centres of the ears.

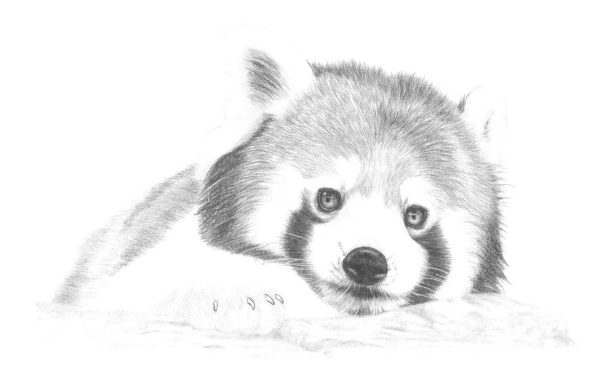

'Take care not to let your pencil tip fall into your indentations and fill them up. You should start to see them stand out white as you work.'

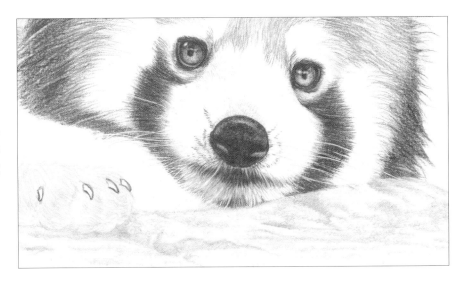

87

5 **Shadows** Now sharpen your 6B pencil and use it to darken the area directly under the chin and out over his paw. Don't be scared to use this pencil; it is very dark graphite but this area on the panda is extremely dark. A red panda has black legs and under body, which is very unusual and in stark contrast with the rest of his coat colour. Keep your hand on your rough paper as you work with the 6B. You must look out for loose graphite particles on your card and blow them away as and when you see them; you will also need to clean your rough paper with your putty eraser periodically. Shade around the indentations where you can and try to not let your pencil tip fall into the whiskers. When you get level with the outer edge of his paw, swap to the sharpened 4B to continue.

Adding texture to fur If you have a good look at the reference picture you will be able to see some texture within the fur; you will see it's not totally black, so try to use the pencil in lighter strokes, the way you have been doing for the fur elsewhere.

Adding more depth Next, sharpen the 4B again and go over the paw in a couple of layers, darkening the hairs you added earlier. Use a sharp 6B to add more depth to the top of the paw and in between the digits.

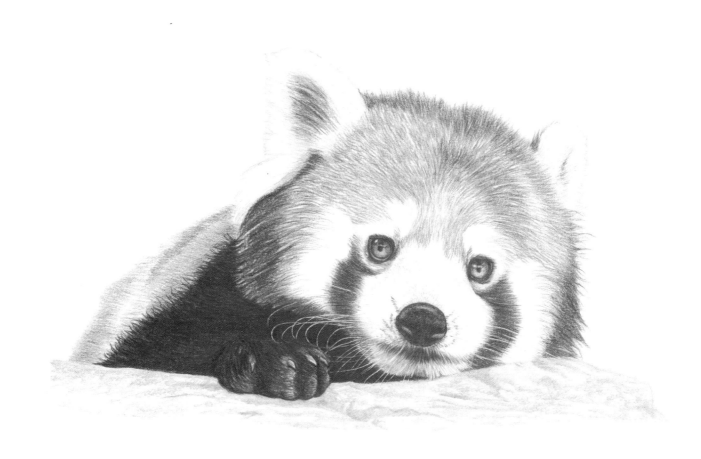

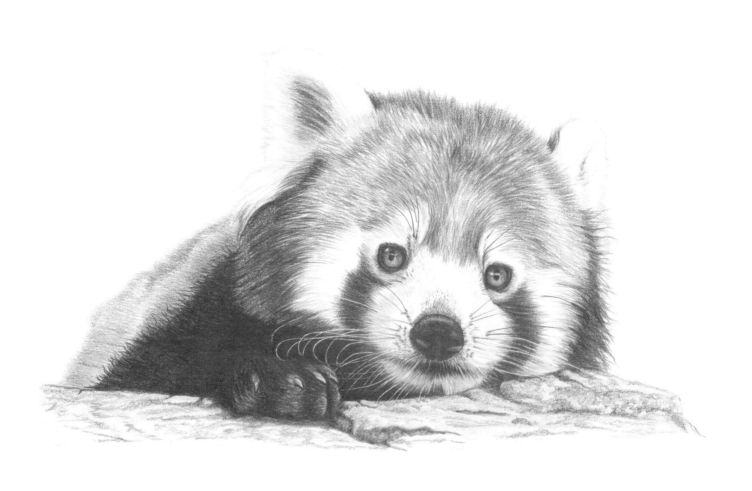

Red Panda Portrait

21 x 30cm (8¼ x 11¾in)
Graphite pencil on smooth white card.

The final stages are all about details and finishing touches. Now that you have your darkest dark completed (the black sections on the panda), you can use this to check against all of the other darks within your drawing. Sharpen your 4B and darken the nose a bit more, using the same shading method as before. While the pencil is still sharp, add all the small hairs above and around the nose and outline the eyes again. Go back over the fur on his head with your 2B and 4B where required and use the 4B to darken his mouth too. Using the 2B pencil with the blunt side of the tip, shade back over the back of the panda where the hair becomes more out of focus. When you have completed this, use the putty eraser to lift off any hard edges so there is no overly defined edge along his back. Use the 2B and 4B to add more detail to the rock face in the foreground and add some shadow under his paw. Finally, sharpen the 2B again and use it to add some black whiskers where you can see them in the reference picture. Tidy up any last bits with the putty eraser, and make sure the background is clean too – again, use the putty eraser to remove any marks or small smudges. The panda is complete.

TIGER

The tiger is one of the most popular big cats but they are also one of the most challenging to draw or paint. It is very easy to get lost when reproducing the stripes, and getting these correct while maintaining the shape and structure of the head can be a bit tricky!

A lot of planning is required for this subject. The more time spent observing and studying the reference photograph before you begin, the easier it will be to complete. I have used the grid to enlarge my reference photograph, in order to make my outline close to 30 x 42cm (11¾ x 16½in) in size, rather than 21 x 30cm (8¼ x 11¾in), which is quite small and would be fiddly to work on.

TIP

Rest your hand throughout on a piece of scrap paper to prevent smudging and to keep your whites as white as possible.

MATERIALS

Smooth white card, 30 x 42cm (11¾ x 16½in): I use Clarefontaine
2H, 2B, 3B and 6B graphite pencils
9B graphite stick
Pencil sharpener
Putty eraser
Embroidery or darning needle
Spare piece of A4 (8¼ x 11¾in) paper, to rest the ball of your hand on while you work

To download and print out the full-sized photograph of the image below, please visit the web page: www.lucyswinburne.co.uk

1 Outline Go through the steps on pages 23–24 to complete your grid on your card, using a 2H pencil very softly so you can erase the grid lines easily when you no longer need them. Beginning with the ear on the left-hand side of the drawing (the highest point of the image), plot where to begin on your card and work down, copying all the details you see within each square. Stop to check now and again that there are the same number of squares between certain points, for instance between the eyes and the jaw. Compare the number of squares on your paper with the number on the grid. This will ensure you have copied over the outline correctly before adding detail. Use an eraser to remove the grid lines before continuing.

Indenting hairs Use an embroidery or darning needle to score the whiskers onto your outline, starting from the root and working out to the tip. This needs to be a very confident sweep of the indenting tool as you can not correct this indentation, so practise on some spare card before you start. When you first shade over this area, use a soft 2B pencil to shade across the indented area, being careful not to let the pencil point fall into the scored lines as removing this will be hard. Your indented whiskers will begin to stand out from your background as you work.

2 **Background** Create a 'soft focus' background behind the tiger, using your 2H pencil slightly on its side (not directly on the point as this creates too much pressure). Work gently and diagonally across the card from the top left-hand corner of your card down to the bottom right-hand corner. (If you are left-handed begin at the top right-hand corner and work down to the bottom left, as this will feel more natural.) Next, use a blunt-tipped 3B pencil to go over the same area with a circular motion, keeping your strokes soft and gentle with very little pressure. The further the tip wears down on the pencil the easier it becomes.

Blending Use a clean dry finger to blend the background in small circular movements, then use a 6B pencil to darken the background further but begin to create some depth by being selective in the areas you use it. Remember that the light is entering the picture from the top left (see reference picture).

Darkening Use a 9B graphite stick to darken the background further, mainly at the bottom. Press a putty eraser onto the background gently and lift off areas to lighten and add more interest.

3 **Stripes** Using a sharp 2H pencil, start to fill in the stripes, beginning at the top of the tiger's head. This makes it easier to map where you are as you work. Work from root to tip, stroking in the hairs while keeping a close eye on the hair direction and shape of each stripe. Make sure you leave the white areas as untouched as possible, and do not forget to fill in the inside of the ears.

Fur When the stripes are complete, begin to add the darker fur between the stripes, again noting first where it changes from dark to white and copying the fur direction.

It is very easy to go wrong at this stage, so take your time and have regular breaks. If you step away for a while, you can quite often pick up a mistake and fix it before you compound it further.

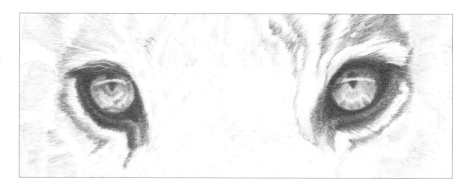

4 **Eyes** Begin with a sharp 2H pencil and start to shade in the iris, taking into account all the markings in both eyes and noting that they are made up of small lines. Alternate between the eyes as you work to keep a balance.

Shadows There is always a shadow cast by the eyebrows at the top of the eyes, as the eye itself is set back in the socket. This shadow is very important and adds a lifelike quality. Begin with this darker section at the top of the eye, and shade from the top of the iris down towards the centre. Leave the highlight that sweeps across the pupil white and continue down, gently shading what you see. Next, use a sharp 2B pencil to darken the shadow at the top of the eye further. Do not be tempted to draw a line around the highlight, just shade around it and give it a fuzzy edge to blend softly into the eye.

Iris Shade the irises of both eyes, working in towards the centres from the outside edges. Next, use a sharp 6B to begin to darken the eyelid and the area of the eye around the outside of the iris. Fill in the pupil, leaving a rough edge to it and darken the brow shadow further at the top. Darken the markings in the eyes where necessary. Be careful not to apply too much pressure with the 6B or a shine will begin to form and this is not reversible. Finally, use a sharpened 9B graphite stick to darken the pupil and around the eye socket further. Again use this softly, as it produces a grainy effect and you can lose detail previously created.

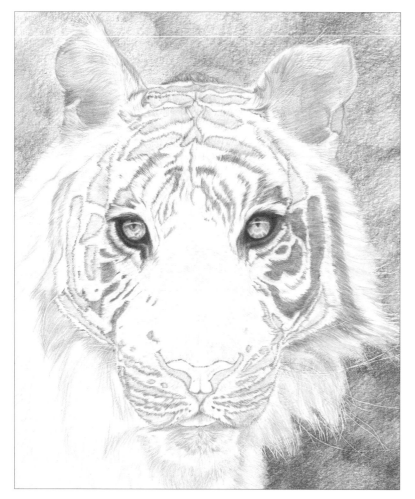

5 **Darkening the stripes** Now that the eyes are complete you have a guide to how dark your stripes need to be. This is best done gradually with several soft layers of pencil. Pressing hard with a high grade pencil will only produce a shine and no depth. Use the 2B to create ragged shapes representing the stripes before filling them in. This prevents you extending the stripes while shading and prevents your tiger ending up with a wonky face! It is very easy to get carried away and lose the shape of the stripes. These are important and follow the bone structure and muscles that give the tiger its striking face shape. Continue around her face being careful to fill in the correct areas. Note that the length of the hair changes when you complete the fur around the sides of her head. Darken the insides of the ears.

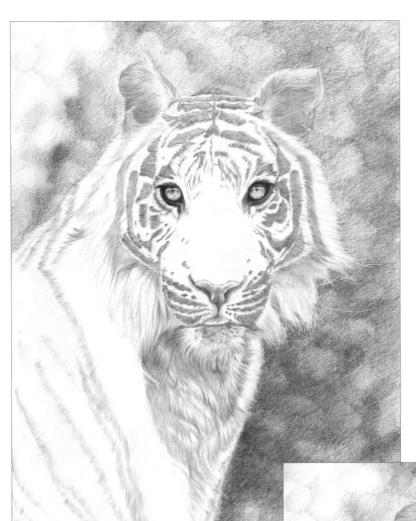

6 Adding depth Continue to work down the tiger with the 2B pencil, keeping it sharp. Add some depth to her nose and begin to build on the 2H layer of pencil already on her chin and neck/chest fur. Keep referring to the original photograph for the hair direction. Darken the stripes across the back of her neck and begin to work down towards her shoulder and chest.

7 Features Now use a sharpened 2H pencil to begin creating the hairs on her nose. This is a complicated section that requires patience, so do take regular breaks! Once the 2H is added all over the nose, begin to darken further with a sharp 2B pencil. Notice how the hairs where they meet the forehead double in length, especially on the bridge of the nose. There is also some scarring on the nose which makes her unique. Use the 2B to darken the fur between the white areas around the eyes, forehead and muzzle.

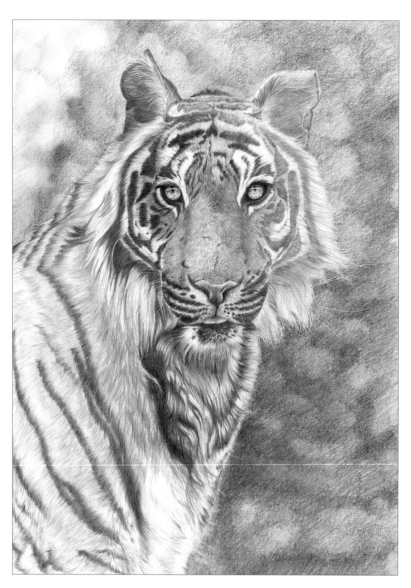

8 **Creating impact** Now you need to add the 'wow factor' to your tiger. Sharpen a 6B pencil and begin to darken the stripes on the head to match the depth of the eyes. Take your time and do not forget to darken the mouth, body stripes and chest fur too. The main picture (left) shows the left side of the tiger's face (right of the picture) still to be darkened further with the 6B pencil, which illustrates how much impact using the 6B pencil has had on the drawing already.

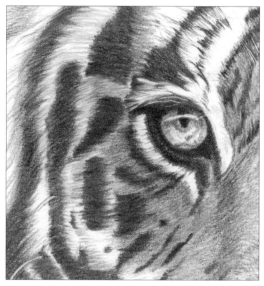

'This close-up detail of the tiger's right eye shows how important the direction of the fur is: your eye follows the contours of the face created by the flow of the hairs. The depth of shading of the mid-tone fur between the white sections of hair must be dark enough to make the white stand out but not so dark that it matches the depth of the black stripes.'

Opposite
Indie
30 x 42cm (11¾ x 16½in)
Graphite pencil on smooth white card.

As you reach the end, continue to work around the tiger using the 6B pencil to darken the fur between the black stripes on the back and shoulder areas. You can also use a 9B graphite stick to darken some key areas if needed. Remember not to press too hard or your darks will become shiny and hard to see. Keep the 6B pencil sharp and work between the white whiskers on her cheeks to darken the fur to help them stand out. If the whiskers are not wide enough or do not stand out quite the way you would like, use an electric eraser tip (not turned on) to gently work along the whisker root and erase selectively to widen them. Lighten the background by rolling the putty eraser into a ball and use it to remove some pencil if it is too dark in places. Darken the left-hand side of the tiger's nose (right of the picture) and face where a shadow has formed. Top up the depth of the pupils and use a putty eraser shaped into a small tip to whiten up the highlights in the eyes. You can also the use the putty eraser to whiten any other areas that need to stand out more. Finally, sign your masterpiece!

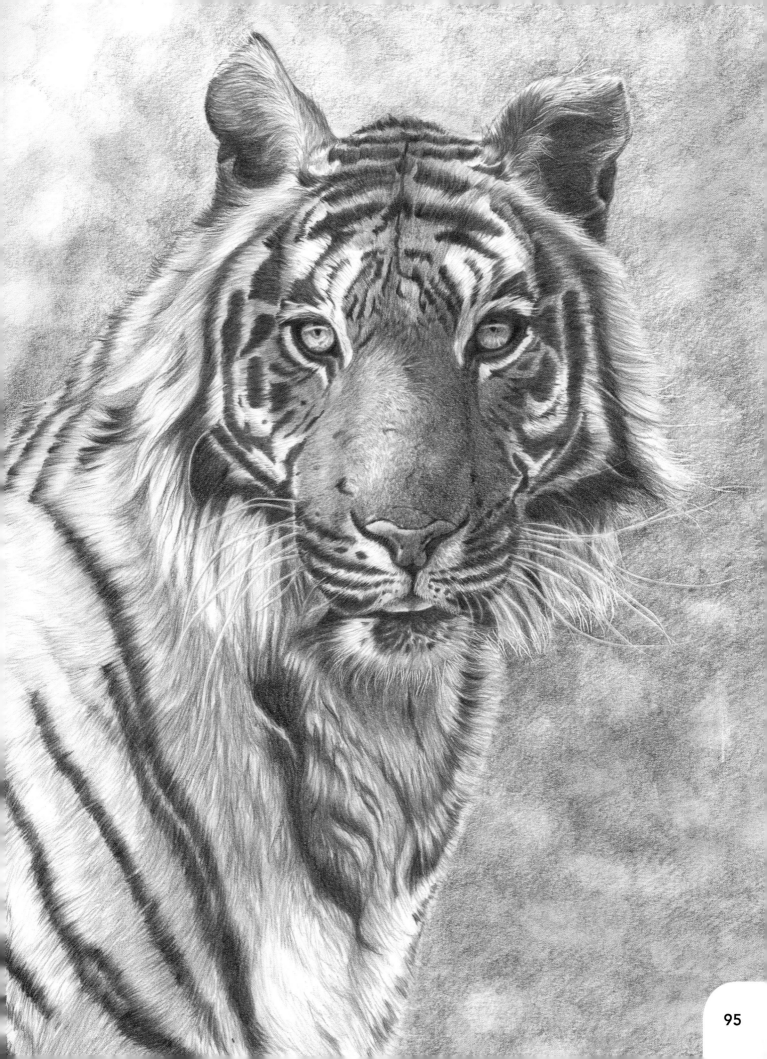

CHEETAH

The cheetah is easily the most elegant of the big cats. Always aloof, they are slender and graceful but possess the stamina to produce speeds of up to 60mph (97kph) from almost a standing start. Unlike lions, they prefer to hunt in the daylight hours, using their speed to take their prey by complete surprise.

As a parent the cheetah is as dedicated as all the other cats, with her litter of up to three cubs staying with her up until they reach two years of age. However, she will bring them up on her own without a support network of other cheetahs, unlike lions who use the lionesses in the pride as adopted aunts. The cheetah has a grace and poise which make her stand out from the crowd.

MATERIALS

Smooth white card, 30 x 42cm (11¾ x 16½in): I use Clarefontaine
2H, B, 3B and 4B graphite pencils
Pencil sharpener
Embroidery needle
Spare piece of A4 (8¼ x 11¾in) paper, to rest the ball of your hand on while you work

To download and print out the full-sized photograph of the image below, please visit the web page: www.lucyswinburne.co.uk

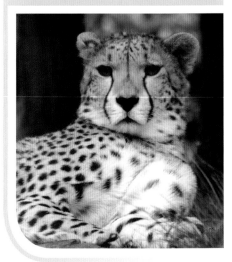

1 **Outline** First, draw the outline using your chosen method of grid, tracing or freehand. This outline is roughly 21 x 30cm (8¼ x 11¾in) in size and drawn in the centre of a 30 x 42cm (11¾ x 16½in) piece of smooth white card with a 2H pencil. Keep your pressure light when drawing this outline so that mistakes are easily erased and rectified. Have a piece of rough paper nearby to rest your hand on as you work, in order to prevent smudging.

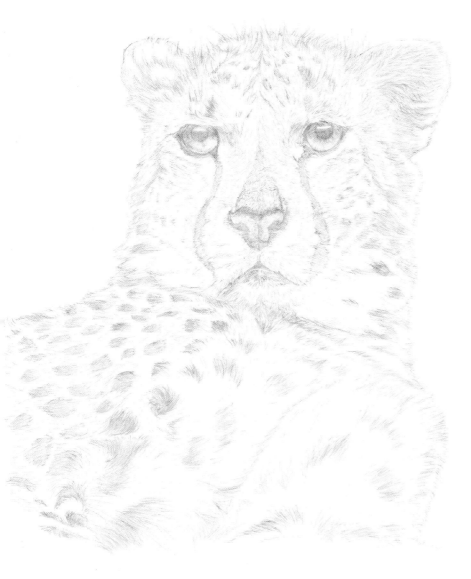

2 **Shading** Before you start shading, decide where you want to indent any hairs or whiskers. The key places are the white whiskers on the cat's cheeks, chin, mouth and the short hairs on the top eyebrow overhanging the eyes. Use an embroidery needle to make the indentations, but be sure to work slowly and with precision as you can not undo these marks.

Markings Continuing with the 2H pencil and, keeping it sharp, begin to work down from the top of the cheetah's head and fill in the spots gently, copying the fur direction from the reference photograph. As you move down the face and body, look back at the reference for changes in fur direction and length. The fur must go in the correct direction to show the position the cat is lying in and the bone structure underneath. Add the light hair to the inner ears and begin to put in a light layer of fur between the spots too. Leave the very white sections of fur untouched so they stand out later. Outline the eyes and fill in the tear track markings on the cheetah's face. Shade in the pupils keeping the edges rough and add some 2H to the iris in both eyes also. Observe carefully where the light sections are in the iris and shade accordingly. Do not forget to add the shadow cast by the brow over the top of the iris and leave the highlights in the pupils untouched.

3 **Establishing tone** Sharpen a B pencil and begin to darken the eyes. Use gentle curved strokes to add a darker shadow to the top of the iris in both eyes and add more depth to the pupils too. Strengthen the lines around the outer edge of the eyes and accentuate the hairs sticking out over the top of the eyes from the eyebrows. When you feel that you can darken no further with the B pencil and that the pencil is skating slightly, sharpen a 3B pencil and repeat the process from scratch to darken the eyes even more. Take time and care to create the eyebrow hairs, keeping them crisp and light and the area underneath dark so they stand out. If done well it can look very effective!

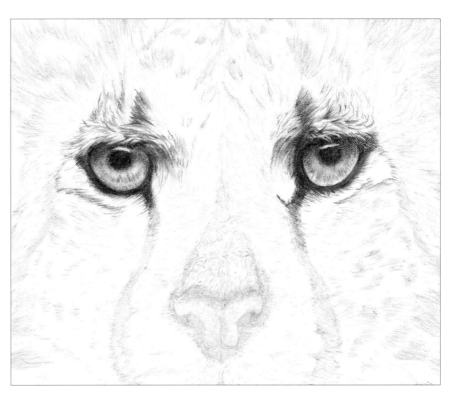

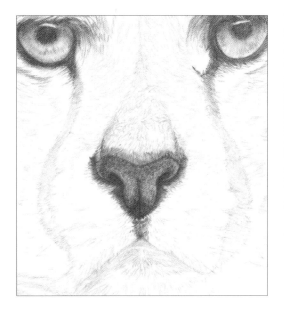

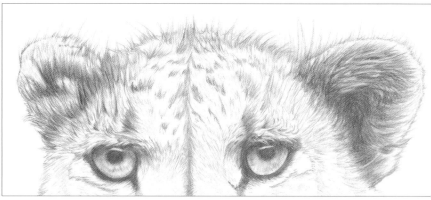

5 Ears Move back to the head again and begin to put in the darker hairs on the top, with a sharp B pencil. Work down the face until you meet the brows again. Keep the pencil tip sharp. Now start to add the darker hairs at the base of the cat's left ear first and outline the whole outer edge of the ear with tiny little hairs, interspersed by slightly longer wispy ones. Next, build up the hairs within the ear itself, studying the reference first for hair direction. Add some B to the inner ear, making the centre as dark as possible. Now use a sharp 3B to darken the ear further in the centre to match the depth of the pupils. Add longer dark hairs at the base of the ear, close to the top of the head and flick them upwards in one fluid motion. The cat's right ear is actually facing backwards, so what you are seeing is the ear almost back to front! This ear is in listening mode... Complete this ear using the B and then 3B as before.

4 Nose Now use a B pencil (with a sharp point) to add some darks to the nose. Begin by checking your outline is correct and then fill in the nostrils gradually making them darker and darker. Next, deepen the darks on the nose itself by using the pencil (which is now less sharp) in small circular movements, to add texture all over. Keep looking at your reference for detail. When you feel the need to apply more pressure to the B pencil to darken your shading further, this is the time to change pencils to a sharp 3B as before. Continuing with the B will only increase the shine and add no more depth. Repeat the process of darkening as you did before with the B pencil.

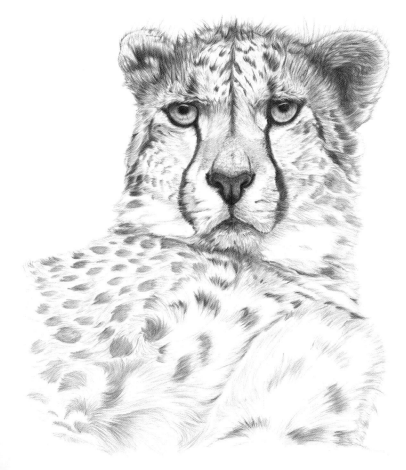

6 Fur Continue back down the face using a sharp B pencil, darkening the tear lines, mouth, chin, right down to the neck, filling in the spots as you go. Shade the spots carefully with the pencil, checking your reference regularly to ensure you keep to the shape of the face in particular. When you get down to the chest fur, keep the pencil movements long and flowing to create the longer hairs. The picture with this step shows the head only with B added, showing the difference this grade of pencil makes. When you have gone as dark as you can with the B pencil, sharpen the 3B again and go back over the head and all details as you did with the B.

TIP

If a particular feature is eluding you (perhaps because the reference is too dark, for instance), use a reference book or go online to find some close-ups of the area you require.

A Class Act

21 x 30cm (8¼ x 11¾in)
Graphite pencil on smooth
white card.

At the final stage,
use the B and 3B to
add some shading to
shape the head and
 body and make them
appear three-dimensional.
Add 4B to darken all of
the spots and other key
areas just a little more.
Finally, add your black
whiskers to the cheeks
with a sharp 3B pencil
and you can relax as your
cheetah is complete!

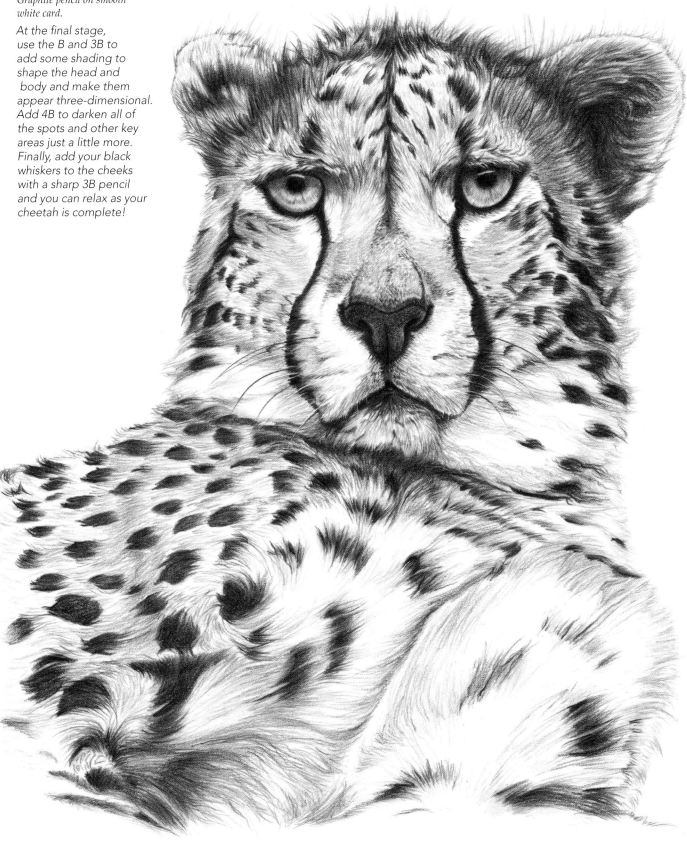

DOMESTIC ANIMALS DOGS

There are many different shapes and sizes of dog, too many to make reference to in this book individually. However, there are a few common shapes that we would all recognize instantly.

Face shapes

Barring variations in size and some particularly unusual breeds, dogs' heads fit into a few broad shapes. These are round head (Pug, Staffordshire, and similar), narrower face with long muzzle (Border Collie, German Shepherd), square head (Bull Mastiff, Labrador type) and finally small and fine-boned pointed face (Papillon, Chihuahua). These pages illustrate two of the more common and distinctive head shapes.

Round head

One of the most common breeds is the Staffordshire Bull Terrier. When drawing this breed, ensure that the ears are almost on top of the head. The eyes are small and set quite far apart, the jaw is square with a wide mouth, compact nose and short muzzle. The main distinguishing feature of this breed is their neck, which is almost as wide as their waist! Staffordshire Bull Terriers are known for their stamina, and their robust build reflects this well.

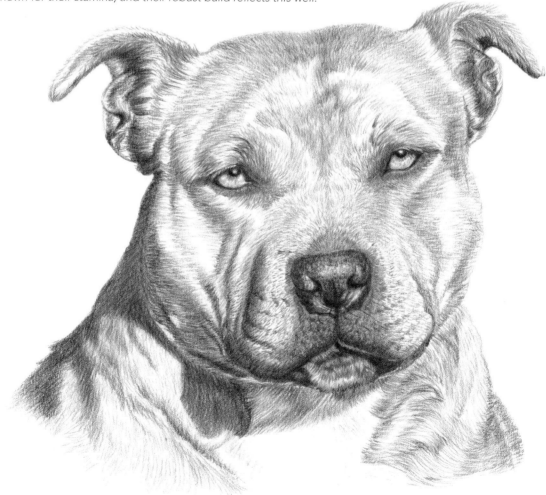

Long muzzle

The Border Collie, another well-known breed, has a narrower face with a long muzzle. The ears are positioned high on the skull at the top and can be pricked (upright) or tipped (folded over).

The coat is not always long; some Collies are short-haired, but the traditional appearance is black and white with medium length fur. The facial colouring of a typical Collie will include a white muzzle and a streak of white fur in the centre of the forehead. This streak can be wide or narrow depending on the dog.

Many Collies are not of pure pedigree and so come in all shapes and sizes, but in general they are light in frame, highly energetic and have an inquisitive expression in the eyes, especially if you are holding a ball!

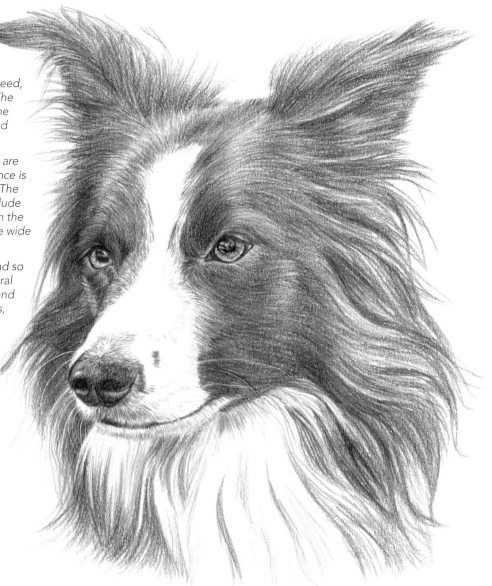

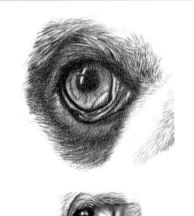

Eyes

Dogs exhibit numerous different eye shapes, but one of the most unusual is the bulbous, deep-set eyes found in breeds of dog like the Pug, Chihuahua and the Bulldog. Bulldogs' eyes (see upper left for an example) are heavy-set, matching their solid and compact body shape. The eye itself is round in shape, with a large brow above. The eyes are set quite wide apart and a lot of the bottom inner eyelid is on show, which is a big characteristic of this breed.

The example eye on the lower left is that of a Rhodesian Ridgeback, but the overall shape is very similar in lots of medium-sized breeds, including Retrievers, Labradors and Hungarian Vizslas. If you drew a diamond to start with, you would not be far wrong. There is a defined brow but it is more refined. There is almost no sign of the inner eyelid and the overall look is clean, crisp and very direct!

Ears

Ears can be amongst the most distinctive features of a dog breed. Easily recognizable are the ears of the German Shepherd (see right). Their most common coat length is medium to long and this includes long hairs within the ears themselves. The ears are usually upright rather than tipped but sometimes a dog will have one ear at least that fails to spring upright and match the other in adulthood. This can be quite appealing!

Another type is the floppy-eared Spaniel (see right). These ears are positioned lower down the skull, about level with the eyes. The ears are narrow at the top and long and bottom heavy. As with the Spaniel's coat the ears are made up of lots of curls, which reflect the light attractively as they fall downwards. The bottom of the ear is almost bell-shaped and blunt cut.

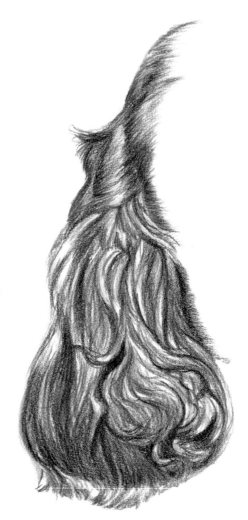

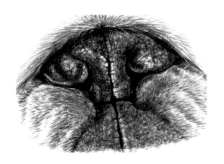

Noses

As with eyes and ears, dog breeds have a few basic shapes of nose. Few are as distinctive as those of the Pug or Bulldog, which are tucked away within the face rather than standing proud of the muzzle like the Border Collie on page 101. The example on the upper left is of a Bulldog's nose. Note how the hair above the nose almost rolls over the top like a protective carpet and the overall texture of the nose itself is quite raised.

In contrast the nose of the Labrador (see the example on the lower left) is very obviously on the end of the face and is the first feature to meet you in a greeting! The nose can be quite large and in different breeds of Labrador or Rhodesian Ridgeback it can be liver-coloured or black. It is smoother in finish and much rounder than the Bulldog's and the fact that it is proud of the face also aids breathing.

Body shapes

Dogs' body shapes vary so much from one breed to another that it is hard to make any but the broadest statements about them in general. However, when it comes to recognizable body shapes I think you will agree that the popular breeds shown here are rewarding to draw. With variation in the proportions, the principles apply to dogs in general.

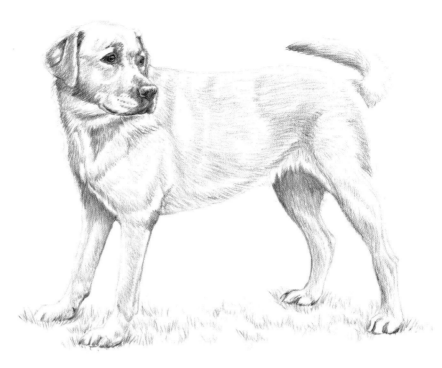

Labrador Retriever

One of the most popular breeds has to be the Labrador. They are of medium build, stand a lot taller than the Staffordshire Bull Terrier and are thicker set than the Border Collie. The Labrador has a square head shape, wide shoulders and a solid, strong body shape. The coat is thick and soft – almost luxurious – and the hair is generally about 5cm (2in) long.

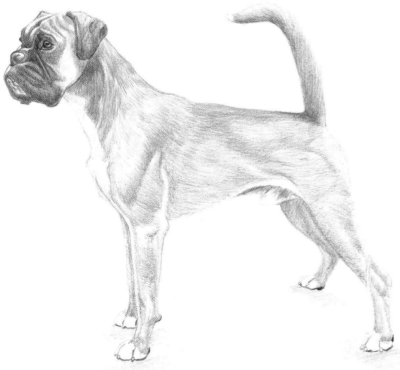

Boxer

Another easily recognizable breed is the Boxer. Their face, with its characteristic lack of profile, is very distinctive! The eyes are set wide apart and are quite round in shape, while the nose is small compared with the size of the head. They have a large jowl and a wide, almost rectangular, head shape. Their expression could be described as 'dopey' but this belies their true intelligence. The ears again are set quite high on the head and are mainly folded over rather than pricked. Their body shape is very front-heavy, with a deep barrelled chest, a strong back with a high waist leading to strong, muscular legs. The Boxer's coat is very short and lies close to the skin, giving it a buffed and shiny appearance when in good health.

POPPY

As we know, dogs come in all sizes, shapes and colours. The subject I am using for this project is a rescue crossbreed called Poppy. Poppy is one of the lucky ones, having found a loving home with the lady who rescued her. I decided to use Poppy in particular as her black and white colouring is an enjoyable challenge to emulate with graphite pencil.

 If you have been following this book from the beginning, you will have noticed that the darker areas are created slowly and methodically, with firm – but not heavy – pressure on the pencils, and the effect built up steadily over several layers. In this lesson you are going to see how to create this dog using a different method: instead of building the depth gradually, the highlights are created using a 4H pencil to help resist the high grade of soft pencil to come and the darks are created immediately using a 6B pencil. Using the method previously taught in the book would use up too much tooth on the card as it is almost non-existent. The method involves going straight in with the dark after highlighting the light areas with a hard pencil, to repel the dark pencil as you shade into and over it in places.

MATERIALS

Smooth white card, 30 x 42cm (11¾ x 16½in): I use Clarefontaine
4H, 2H, 3B and 6B graphite pencils
Pencil sharpener
Putty eraser
Embroidery needle
Spare piece of A4 (8¼ x 11¾in) paper, to rest the ball of your hand on while you work

To download and print out the full-sized photograph of the image below, please visit the web page: www.lucyswinburne.co.uk

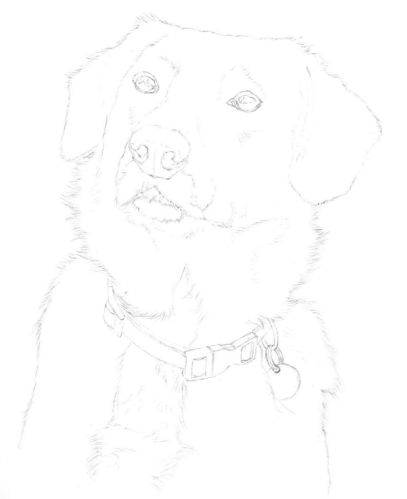

1 Outline Draw the outline using your chosen method of grid, tracing or freehand. This outline is drawn in the centre of a 30 x 42cm (11¾ x 16½in) piece of smooth white card with a 2H pencil and the drawing is around 21 x 30cm (8¼ x 11¾in) in size. Keep your pressure light when drawing this outline so that mistakes are easily erased and rectified. Do not forget to have a piece of rough paper ready to rest your hand on as you work to prevent smudging.

Indenting whiskers Before beginning to shade, use an embroidery needle to indent the dog's whiskers on her muzzle, starting from the root and working out to the tip. This stage is irreversible so make sure you know where your whisker is heading before you start at the root.

2 Face Start to add highlights on the right-hand side of her head using a sharp 4H pencil. Begin with the top of the ear and add all the light areas with gentle strokes on the surface of the ear. Now add the 4H to the shiny areas on the top of her head with shorter strokes, following the hair direction from your reference picture. Reaching the eye, add the lines which curve over the eye brow bone, underneath the eye and then leave a gap for the dark 6B area to come. Continue again with the 4H, referring to the photograph to get the areas of shine on her face correct. Add some 4H in the curve where the hairs flick out on the right side of the face adjacent to the muzzle. Begin to mark out the white hairs above the mouth on the front of the muzzle using the 4H.

Strengthening Sharpen a 6B and go back up to the top of the head. Begin to fill in all the dark sections starting directly above the eye, gently running the 6B into and through the 4H lines already laid previously. You can use the 6B to fill in the corner of the eye working upwards towards the brow and then move to the top of the brow bone and shade from left to right into the 4H lines. This filling in from both directions means you properly integrate the highlight by shading from both ends so it becomes part of the dark area. Continue to work around the eye with the 6B and then work down to the area under the eye and beyond. Your previously marked areas in 4H should now be showing as lighter highlights within the 6B shaded sections. When you reach the indented whiskers ensure that you shade across them, not horizontally along the length of them, as you could inadvertently fill them in. As you cross them with the 6B and build up with a couple of layers, they will begin to show up more. Go back to the eye and use a 2H to add a soft layer to the iris and pupil, leaving the highlights in the pupil untouched. Use a sharp 3B to darken the pupil and iris further. Outline the eye with this pencil and then sharpen your 6B to darken the eye overall.

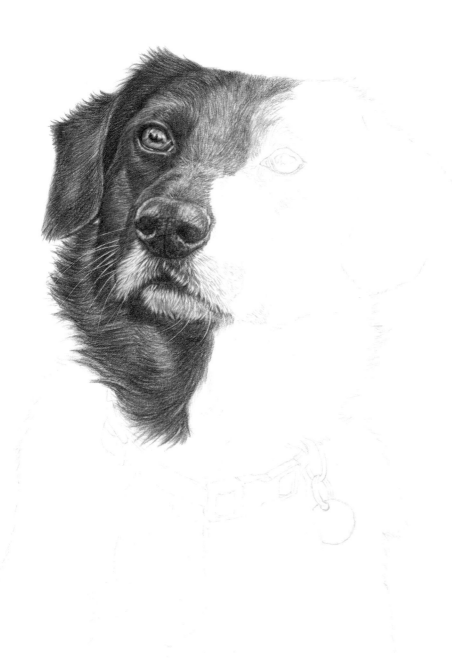

3 **Features** Go back to the top of the head and sharpen the 6B before adding the darks to the already prepared ear. Make sure you have added enough 4H to keep the highlights before you fill it in completely. If there are insufficient highlights left on the ear, use the putty eraser to lift some pencil off. Move down to the muzzle again and use the 4H on the chin hairs as you did before to create the white hairs above the lips. Now use a sharp 2H to add more detail to these hairs, taking care to keep them as white as possible. Next use a sharp 6B to shade in the dark area between the lips and take some 6B into the hairs overlapping the mouth. Fill in the area under the chin using the 4H again first for any highlights, then shade the darkest areas with a 6B pencil and then a 3B pencil.

TIP

Building up in layers from light to dark ensures a sharper finish to the nose than if you go straight in with the 6B.

4 **Nose** To complete the nose, sharpen a 2H pencil and use this to add the first layer of texture to the nose. Study the reference. Use a combination of a scribble technique plus small, crisp lines to create this texture. Fill in the nostrils. Next, use a sharp 3B pencil to darken the nose further, building on the texture you have created. Darken the nose where required and add more depth to the nostrils. Finally, sharpen a 6B and darken the nose further using two or three layers of pencil. Again, use the putty eraser to help lift off the highlights if they are not obvious enough.

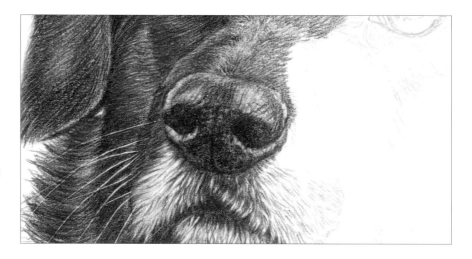

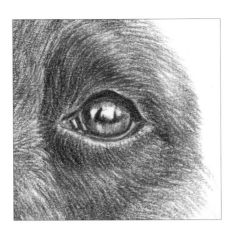

5 **Features** Use the 4H to create the short highlighted hairs on the section above the nose, making sure that the hair direction is correct as you work towards the area between the dog's eyes. Use the 4H right up from between her eyes to the top of her head. Next use a sharp 6B to shade in from the top of the nose towards her eyes again. Fill in right up to her forehead and onto the top of her head. To complete her left eye use the 4H again to add all the highlights as you have done previously. Use the 4H in all the light areas on the brow bone above the eyelid and below the bottom eyelid, completing those in the cheekbone too. Sharpen the 6B and begin by outlining the dark line beneath the iris and filling in the corner of the eye. Next, darken the area inside the eyelid and above the iris, then fill in the pupil using the 2H and 3B first, leaving the highlights untouched, as on the other eye. Darken the eye further using a sharp 6B. Now use the 6B to complete the darks above and below the eye and then work the 6B into and over the 4H already applied on the cheekbone.

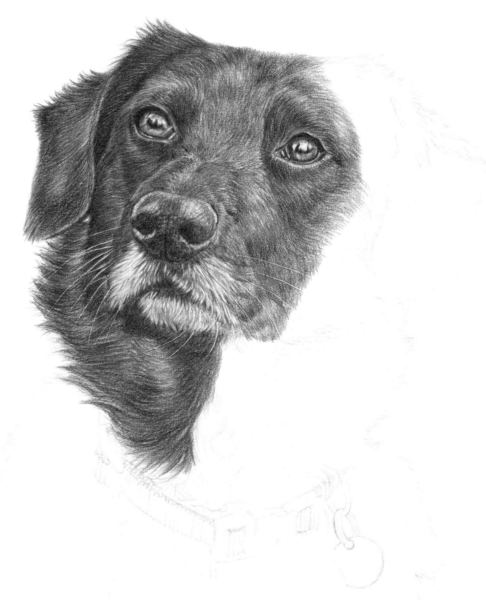

6 Fur Continue to work down the left-hand side of the dog's face by first adding 4H to the light areas and then 6B to fill in the darker sections. Work down towards the collar, slowly and methodically. When you reach the white section of fur in the middle of her neck, use a sharp 2H to draw in the segments of white hair and use a sharp 3B to add a little shadow within the white to break it up and separate the hairs. Darken the shadow under the chin, so that her muzzle comes forward out of the card.

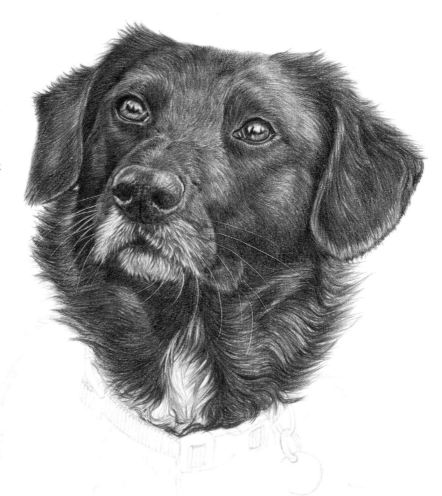

7 Details To complete the collar, shade in the material part with a sharp 2H pencil first. Outline the buckles and metal rings with this pencil once the material is established. Next, shade in the material again and add some texture, still using the 2H, and use the same pencil to shade the buckles and rings, leaving the highlights untouched. Now sharpen a 3B pencil and darken the black plastic buckles and material section further. Continue to add more layers to darken the collar overall.

Opposite
Poppy
21 x 30cm (8½¼ x 11¾in)
Graphite pencil on smooth white card.

At the final stage, build up the white fur centre section below the collar as you did before on the white fur above, using the 2H and 3B pencils. Sharpen the 6B and add a little shadow and a few black hairs within the white fur. Build up Poppy's neck and the top of her shoulders using the 4H to add the highlights and a sharp 6B to create the darks. Clean up the background with a putty eraser and use the same eraser to lift off and bring out any highlights that require polishing up.

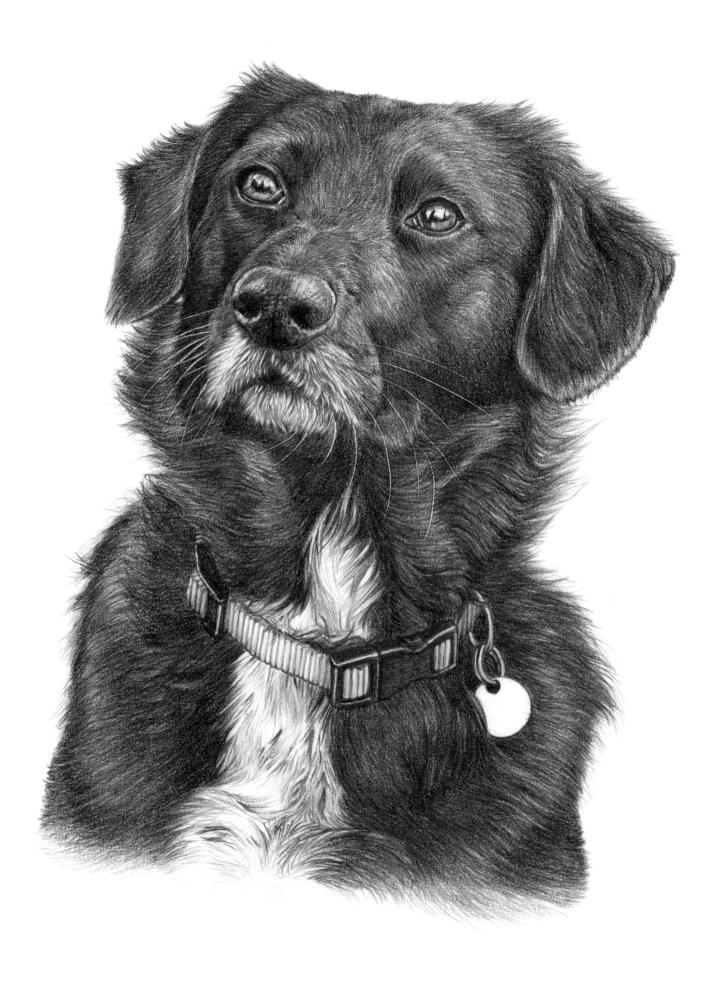

CATS

Body shapes

When it comes to feline body shapes there are really only a few 'cat'egories (pardon the pun). Most cats fall into one of three basic shapes: the typical non-pedigree varieties, the rather heavy-set Persian type and the tall, slim Siamese. Of course there are variations but these are the most common.

Heavy-set

This cat has long hair, thick legs, a wide body, a large head and a heavily-plumed tail – all typical characteristics of the Persian body type. There is often a large ruff of fur around the neck, particularly on this particular breed type (the Blue Smoke). The cat is typically blue-grey all over with the head and body being darker than the rest. Some have faces so flat there is almost no profile at all, but this illustration is of a cat with a less extreme face shape.

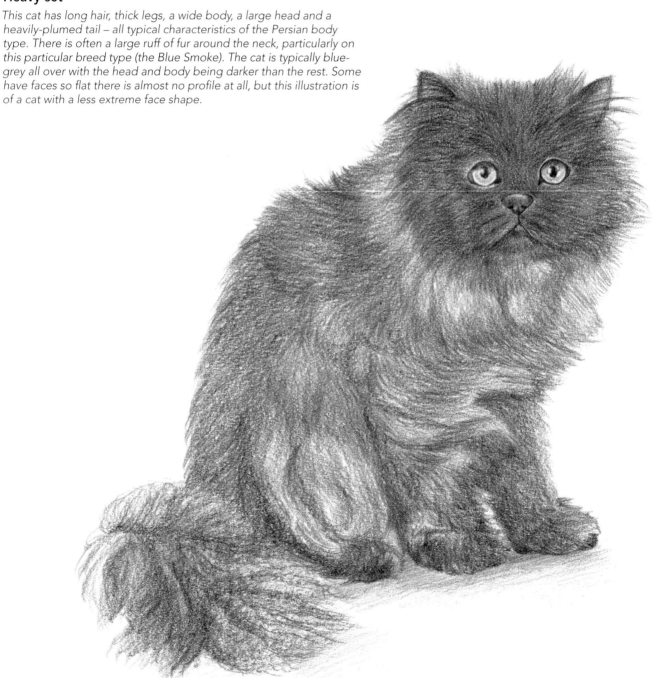

Slim

Siamese cats are one of the most vocal breeds I have ever come across! They are very elegant and agile but are not everyone's cup of tea. Their body shape is typically tall, very slim with long legs and an almost triangular head. The eyes are often a piercing blue, and like the ears are quite large in proportion to the head.

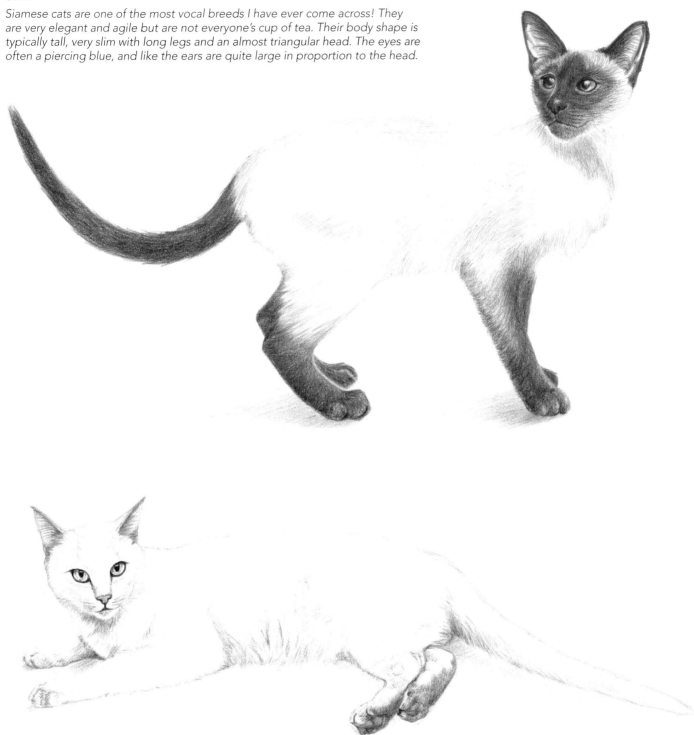

Typical

This type of cat can vary quite considerably in colour and fur length due to breeding being unregulated. The illustration shows a white cat. The body shape is generally slim, very commonly short-haired, slim-legged and not as stocky as the pedigree. There are long-haired varieties of the non-pedigree too, but the most common seems to be the short-haired black cat, of which there seems to be an abundance!

Eyes

All domestic cats have slit shaped pupils (unlike most big cats), though the pupils appear very full and round in the dark. The shape of the face and eyelid affects the outer appearance of the eye, as illustrated below.

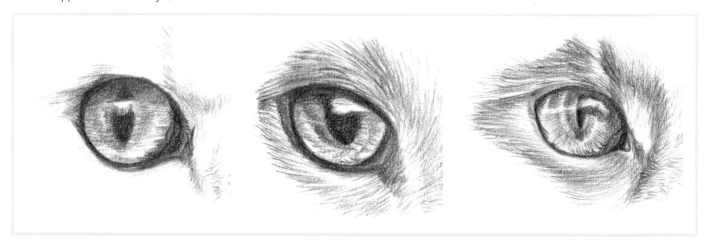

Persian

Whether they be a Persian cat or a British Blue Shorthair, this type of cat always has eyes that appear round and quite large.

Siamese

The eyes of a Siamese cat are almond-shaped and very pretty. They are quite easily recognizable as they have a slanted eyebrow, making them point up at the corner.

Non-pedigree

The eyes of the non-pedigree (affectionately termed 'moggy') cat can vary, especially if the individual is made up of a mix of pedigrees. This eye illustration shows the shape of a basic non-pedigree cat such as the example on page 111. The eye is rounder than the Siamese but with no slant to the eyebrow.

Head shapes

As with the typical body shapes illustrated earlier, the most familiar head shapes of cats are the pedigree Persian or Exotic Shorthair, the Siamese and the different types of non-pedigree cat.

Exotic Shorthair

It is quite apparent that the face shapes of the Exotic Shorthair and even that of the Persian Longhair are very round. Both types of cat have matching circular eyes, short rounded ears and the profiles of their faces are very flat as the noses hardly protrude at all.

The cheeks are quite full and the mouth tends to look downturned, giving them a slightly sad expression.

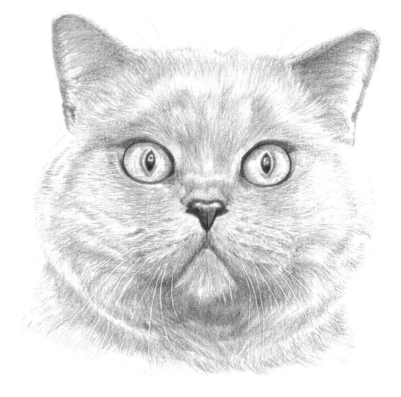

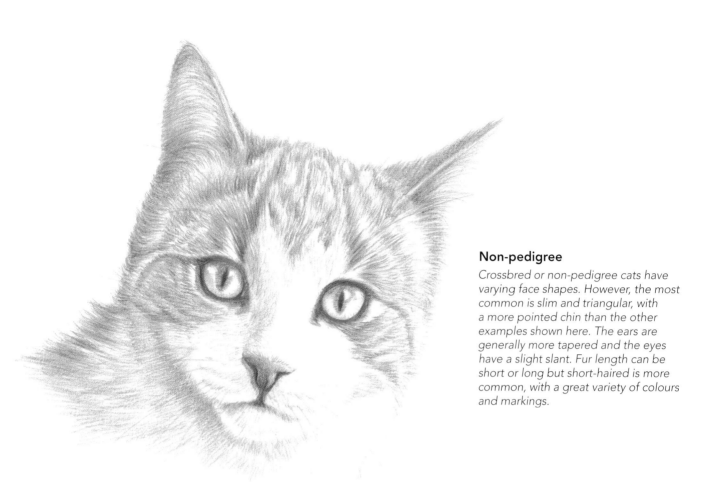

Non-pedigree

Crossbred or non-pedigree cats have varying face shapes. However, the most common is slim and triangular, with a more pointed chin than the other examples shown here. The ears are generally more tapered and the eyes have a slight slant. Fur length can be short or long but short-haired is more common, with a great variety of colours and markings.

Siamese

The Siamese cat also has a triangular face shape which is very lean and angular. They usually wear a very aloof expression and their eyes are a very distinctive shape and colour. The ears and nose are quite dominant in this breed, making them appear very striking: there is no mistaking a Siamese when you see one!

The profile of the face is the total opposite of the Exotic Shorthair on the facing page, with the angles of the face making it protrude quite prominently when viewed side-on.

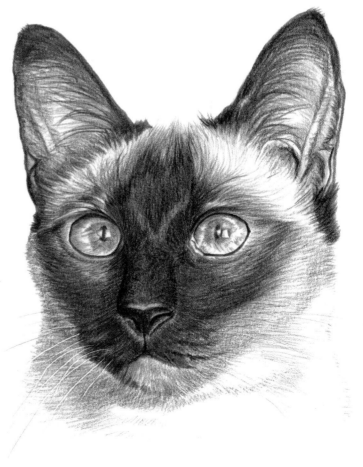

TOM

There are all sorts of cat I could have used for this project but I wanted to use a shorthair to demonstrate the shape of the eyes and face fully and clearly. This particular cat is owned by a lady who runs a well-known cat rescue centre and he was a rescue himself. He is a young ginger tomcat, full of energy and extremely inquisitive. I just managed to capture this photograph of him before he shot off on yet another adventure...

MATERIALS

Smooth white card, 30 x 42cm (11¾ x 16½in): I use Clarefontaine
4H, 2H, 3B and 5B graphite pencils
Pencil sharpener
Putty eraser
Embroidery or darning needle
Spare piece of A4 (8¼ x 11¾in) paper, to rest the ball of your hand on while you work

To download and print out the full-sized photograph of the image below, please visit the web page:
www.lucyswinburne.co.uk

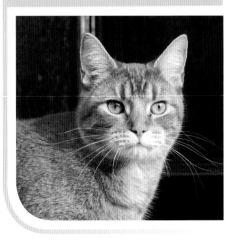

1 Outline Draw the outline using your chosen method of grid, tracing or freehand. This outline is drawn in the centre of a 42 x 30cm (16½ x 11¾in) piece of smooth white card with a 2H pencil and the drawing is around 30 x 21cm (11¾ x 8¼in) in size. Keep your pressure light when drawing this outline so that mistakes are easily erased and rectified. Remember to have a piece of rough paper ready to rest your hand on as you work to prevent smudging.

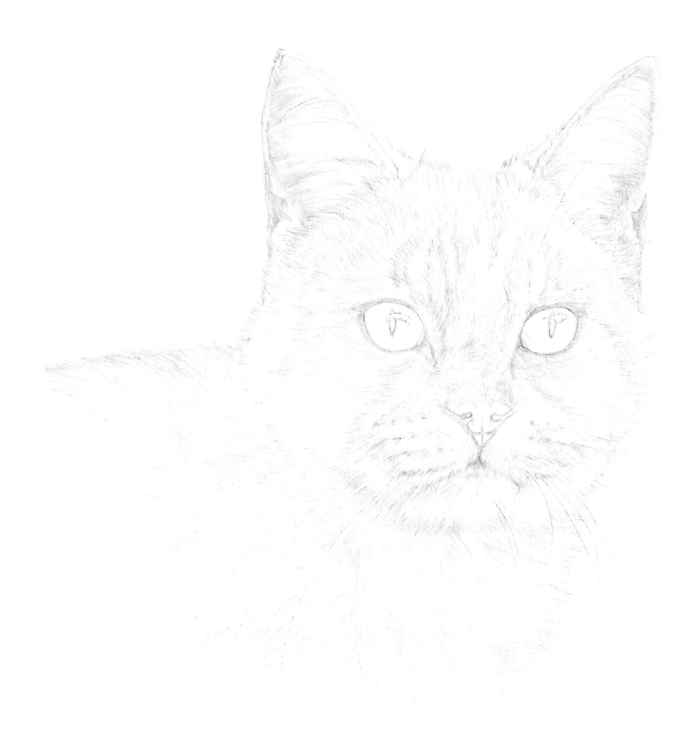

2 **Indenting whiskers** Before beginning to shade, use an embroidery needle to indent the cat's whiskers, starting from the root and working out to the tip. This stage is irreversible so make sure you know where each whisker is heading before you start from the root.

Fur Select a 4H pencil. Starting at the top of the head or between the eyes – my favourite starting point – begin to add a light layer of short fur. Make sure you follow the hair direction from your reference picture, as a cat's facial hair can be complicated. When you get to the darker areas of fur, use the pencil more sparingly or it will repel the heavier grades of pencil later on when you try to darken further. Take care as you come to the indented hairs that the pencil tip does not slip into the indentations and fill them in. Keep the pencil marks lighter still when you come to the white sections of fur, concentrating more on adding the fur in the shadowed sections. Continue until your cat looks similar to the picture above.

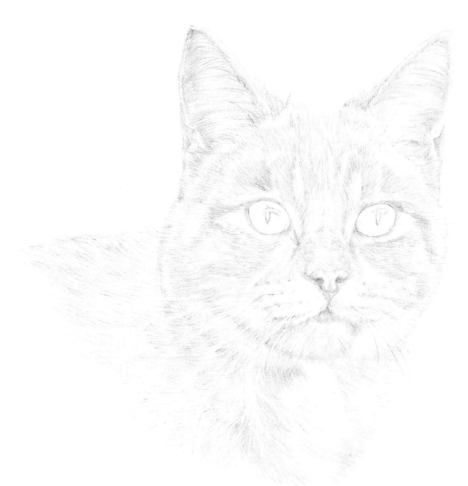

3 **Developing the fur** Use a 2H pencil with a fairly sharp tip to go back over the darkest areas of fur on the cat, all over from the tips of his ears down to the back of his neck. Keep your touch light, or you will fill up the tooth of the card, preventing you from adding the darker grades of pencil later.

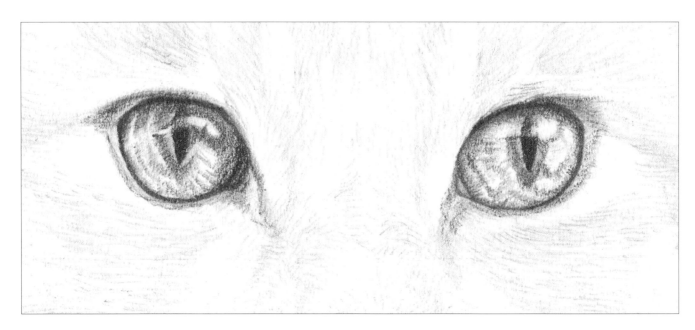

4 **Eyes** Begin by using the 2H pencil again and make sure that it has a reasonable point. Gently fill in the pupils, carefully working around the highlights in the eyes. Add the dark shading around the pupil and create all the lines and markings within the iris, keeping your touch light. Put in the shadows cast by the eyebrows and darken the corners of the eyes. Add another layer of 2H in all these areas again. Next, use a sharp 3B pencil and go back over all the same places again, darkening further. Be careful though not to over-darken all the little markings within the iris. Finally, use a sharp 5B pencil to darken the pupils, the outline of the eyes and the shadows on the top of the eyes to complete the process.

5 **Tonal work** Now that the eyes are complete, select the 3B pencil and begin to darken the fur working from the ears down. Take care to work around and between the hairs in the ears. Continue down the cat's head, remembering to leave some white spaces for the pale fur between the markings. Keep referring to the original photograph for the hair direction as you work. When you reach the eyes work carefully around them. Carry on down towards the nose and cheeks and keep going until you have covered the whole cat in 3B.

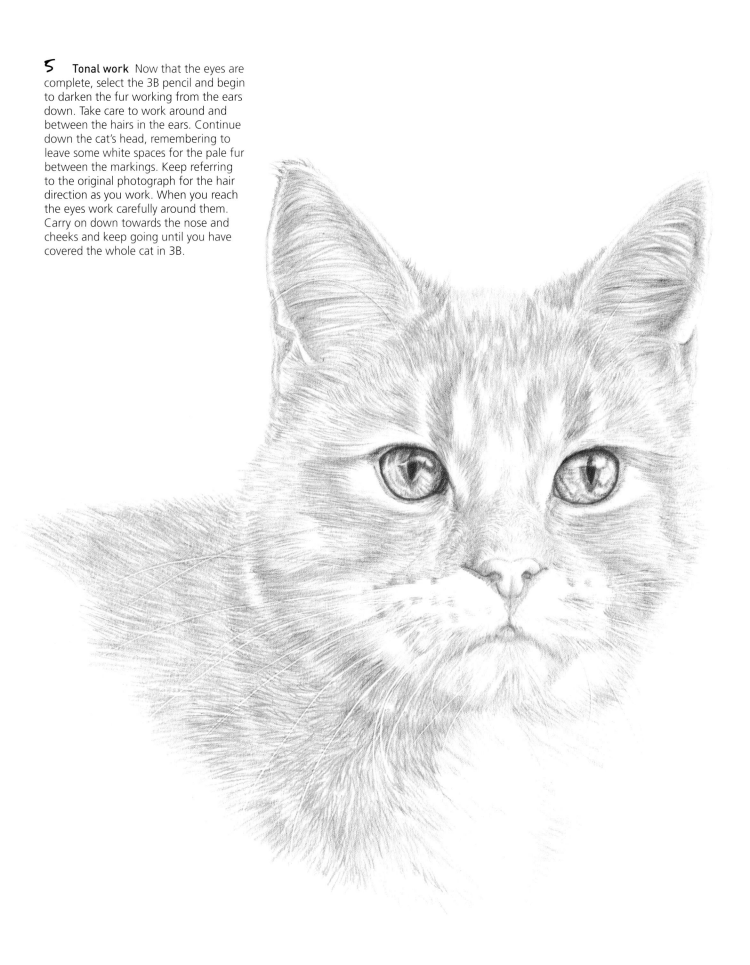

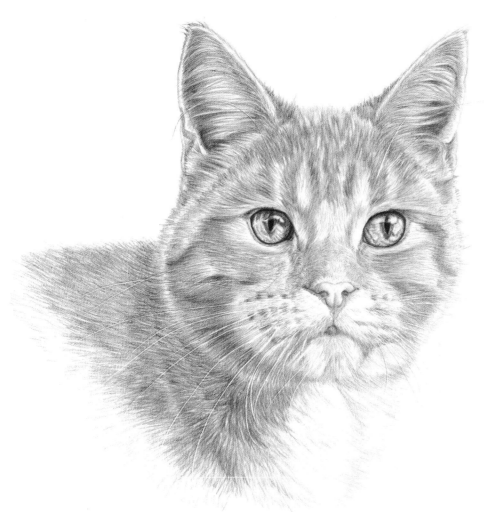

6 Adding depth Go back over the cat again with the 3B to add even more depth. Use a firmer hand and make sure your pencil has a good point. Do not forget the darkest markings go on the forehead and cheeks. Darken the cat's fur on his neck and back also. Add more 3B to the spaces between the hairs in the ears.

7 Details Use the 2H pencil to add all the short light hairs in the lightest areas on the forehead, around the eyes and on the cat's cheeks. You will also need to use this pencil to create the roots of the whiskers as they flick out from the face and into the background.

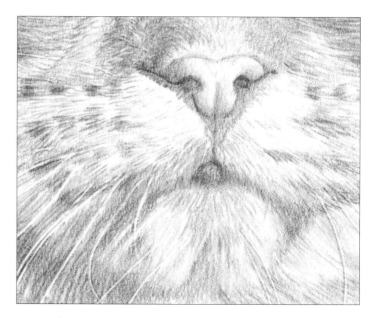

TIP

This is quite fiddly to do. You may find it easier to turn your card upright to make drawing the whiskers in less difficult.

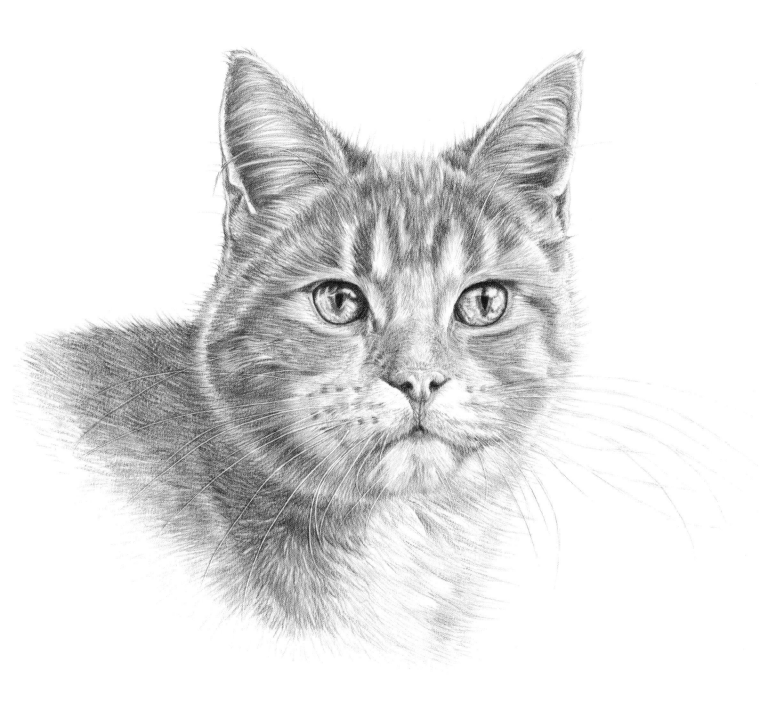

Tom
30 x 21cm (11¾ x 8¼in)
Graphite pencil on smooth card.

At the final stage, use a sharp 5B pencil to darken all the markings gently,
beginning with the cat's head. Deepen the shading in the eyes if required,
darken the nostrils and the nose itself slightly and top up the shadow on the
cat's back, behind his head. Go back over his outline and flick out some wispy
hairs to fluff him up and complete the picture.

HORSES

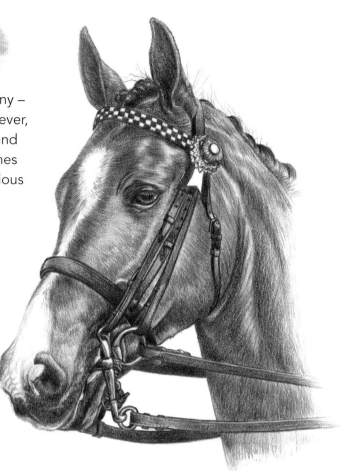

There are many different breeds of horse and pony – far too many to cover in detail in this book. However, on these pages are a few of the more common and distinctive examples, which will help when it comes to drawing the head and body shapes of the various kinds of horse.

Head shapes

Thoroughbred

A very popular horse, the thoroughbred's head shape is long and lean with all elements in proportion. The ears are tall and slim, the eyes medium in size and shape and the face lean and muscular. The nose and nostrils are well defined and a deep mouth makes the appearance of this horse dependable and trustworthy.

Arab

Arabs are known for their feisty temperament and flighty body movements, but no one can deny their beauty and grace. The head shape is very different from that of any other horse or pony breed. There is a strong dip in the profile between the eyes and the beginning of the nose which is extremely defined and singles this breed out as special. The eyes are large and the nostrils are wide and flared, giving the horse an edgy and highly strung appearance. They are my personal favourites.

Body shapes

Shetland pony

The Shetland pony has one of the more distinctive body shapes. The body is short in length and height, and the stocky legs complement the overall stout appearance of this pony. The head is always short and wide but the overall look of the pony is very appealing. Their forelocks (fringes) and manes are often long, and can grow to cover their eyes. Their tails can be so long it looks as though they could trip up on them! The coat length and colours can vary considerably from fine short hair to long and thick, and the colours from mushroom to black and white spotted.

Welsh cob

Another interesting body shape is that of the Welsh cob. There are many variations on coats and colours but the basic body shape remains the same. The overall look is sturdy and muscular. The head is shorter than the thoroughbred's with a wide Roman nose. The muzzle is deep and strong and the head sits on a well-proportioned neck. The body length is neither short nor long but the legs are well-defined and thickset in order to carry the heavy body. There is a powerful and determined look to this breed and they are known for their stamina.

DEE

This study is of a breed of horse called the Irish Draught, which (as the name suggests) originates in Ireland. Speaking from experience I can say that they are very laid back, extremely intelligent and particularly people-orientated. As horses they are brilliant all-rounders, and can turn their hooves to hunting, jumping, eventing or even dressage – a bit like those people we all knew at school who were good at everything!

Originally a chariot horse, the Irish Draught evolved to become the perfect family horse. He was a farm horse during the week, took his master hunting on a Saturday and was fully capable of pulling the family horse trap to church on a Sunday.

The model in the photograph is my friend's horse, Dee. He has all the qualities I listed earlier and combines them with a quiet and calm beauty that is a special quality in a horse. I have a huge soft spot for him and I am sure you will too when you have finished his portrait.

MATERIALS

Smooth white card, 30 x 42cm (11¾ x 16½in): I use Clarefontaine
2H, B, 3B and 4B graphite pencils
Pencil sharpener
Putty eraser
Spare piece of A4 (8¼ x 11¾in) paper, to rest the ball of your hand on while you work

To download and print out the full-sized photograph of the image below, please visit the web page: www.lucyswinburne.co.uk

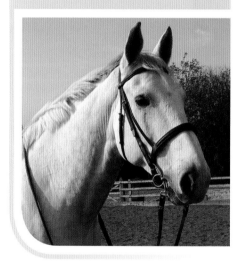

1 Outline First, draw the outline using your chosen method of grid, tracing or freehand. This outline is drawn in the centre of a 30 x 42cm (11¾ x 16½in) piece of smooth white card with a 2H pencil and the drawing is roughly 21 x 30cm (8¼ x 11¾in) in size. Keep your pressure light when drawing this outline so that mistakes are easily erased and rectified. Tuck a piece of scrap paper under your hand as you work to prevent smudging.

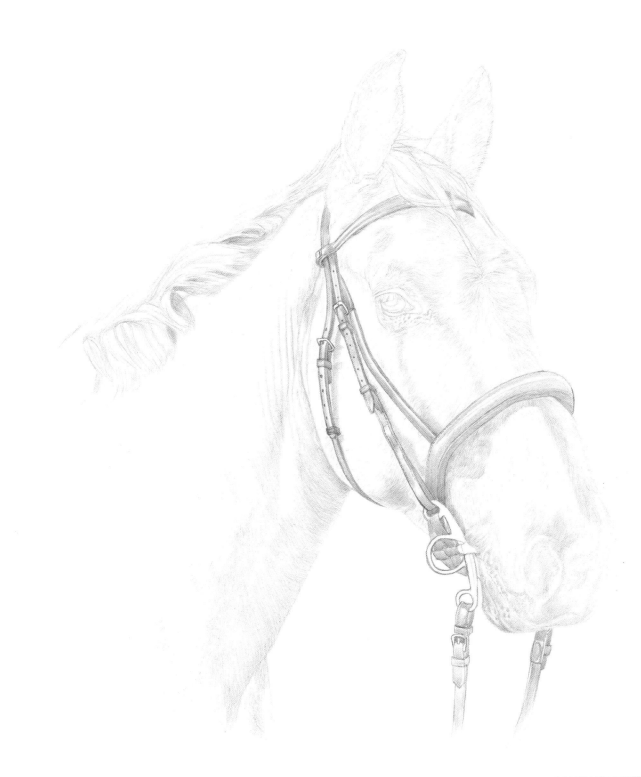

2 Ears and hair Gently put in the hairs in the inner ears and outer edges using soft strokes of a fairly sharp 2H pencil. Note how short the hair becomes on the horse's head compared with the insides of the ears. As you work on the horse, use your putty eraser to lighten the outline around the outside before you fill in each particular area. This is a light horse and you do not need a dark outline around the outside. As you work down the face, keep the hairs you can see very light and short.

Bridle shadows Add the shadows cast by the bridle as you work, shading in the same direction as the hairs underneath. If you add too much dark anywhere and the horse is looking too grey, simply shape your putty eraser, press it onto the area you wish to lighten and lift off, repeating until you have the desired effect. Unless you feel you have really overdone it, try to wait until you have added a darker grade of pencil so that you can be more objective before making any alterations.

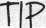

To ensure a very light touch with your pencil, hold the pencil near the end furthest from the tip so that the pencil is almost horizontal in position. This makes applying too much pressure almost impossible.

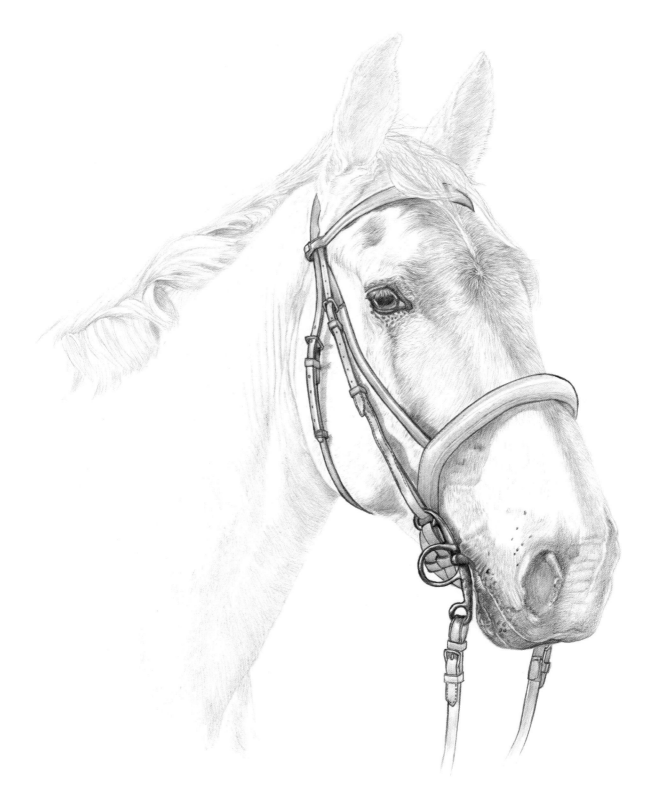

3 **Bridle** Use the 2H to add the base coat of shading to the bridle, leaving the highlights untouched. The texture for the bridle leather needs to be smooth and flat, apart from where the straps bend to go through the buckles. Go over the bridle at least twice with the 2H to darken further.

Eye Gently add some shading to the eye now. Create the eyelashes which overhang the eye and flick out slightly at the ends. The eyelashes are very important and as you work on the eye you must gently work around them to ensure they continue to stand out. Shape the putty eraser and use it again to pick out the lashes if you fill them in by mistake. Fill in the iris and outer eyelids. Draw in the hairs above the eyebrow and those under the eye also. Darken the inner ears further and add some more 2H to the mane and shadows underneath it.

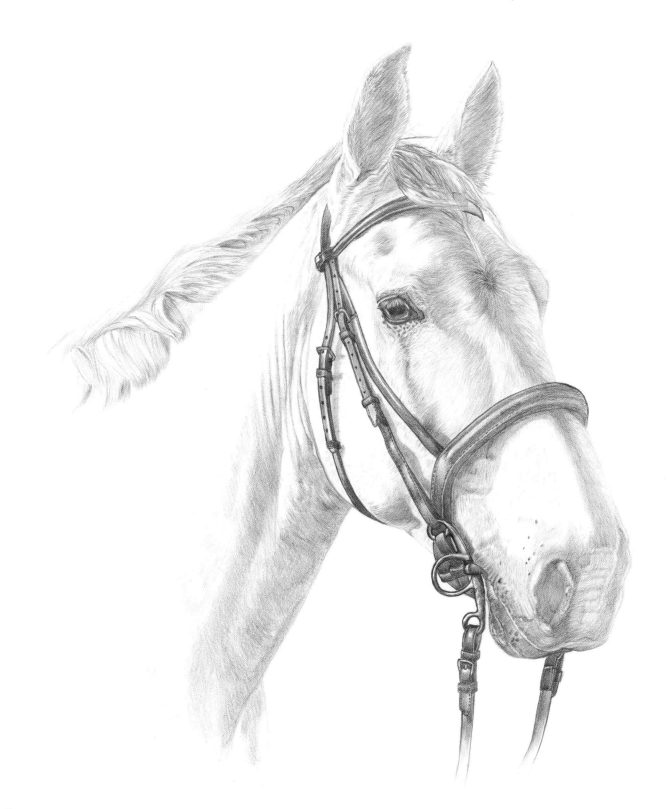

4 **Bridle and metalwork** Outline the bridle again, this time with a sharp B pencil, including all the metalwork. This will help contain your shading when you fill in the bridle leather again later with the B pencil. Use the 2H again to fill in any metal buckles and the clip and rings on the bit in his mouth.

Face Continue to shade down the horse's face with the B pencil, darkening the left side of the face (right of the picture) where the shadows are most prominent. Add more B to the 'star' shape in the centre of his forehead and deepen the shadows cast by the bridle as before. Begin to add more depth to the muzzle, still using the pencil softly and building slowly layer by layer. Darken the inside of the nostril and consult your reference for the correct shape of the lips. Create more darks in the mane, fringe and in his ears.

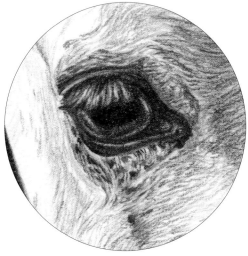

5 **Details** Fill in the bridle now. Work slowly to produce a smooth finish on the leather, pressing softly and layering until it becomes darker. Use the B now the point has worn down to top up all the shadows again and darken the shadow running the length of his face in the centre, so you can clearly see the divide between light and shade. Add some mottled shading to the underside of the neck and darken the shadows in the creases too. Add more shading to the pupil and iris.

Opposite
Dee
30 x 42cm (11¾ x 16½in)
Graphite pencil on smooth white card.

To finish the portrait, sharpen a 3B pencil and go back over the whole horse darkening the eye, forehead, muzzle, bridle, all shadows, mane and ears all over again. When the 3B seems unable to darken further, use a sharp 4B. Be selective with this pencil; as it is very soft and grainy, use it only for the darkest of darks. Suggested areas are the nostril, darkest edges of the bridle, inner ears, underside of the neck and a little on his lips. Lift off a layer or two of pencil with the putty eraser if you have gone too dark in places and whiten up any bright highlights. Touch up the eye area too, if required, and check the background for any smudges of pencil. Now congratulate yourself on a job well done!

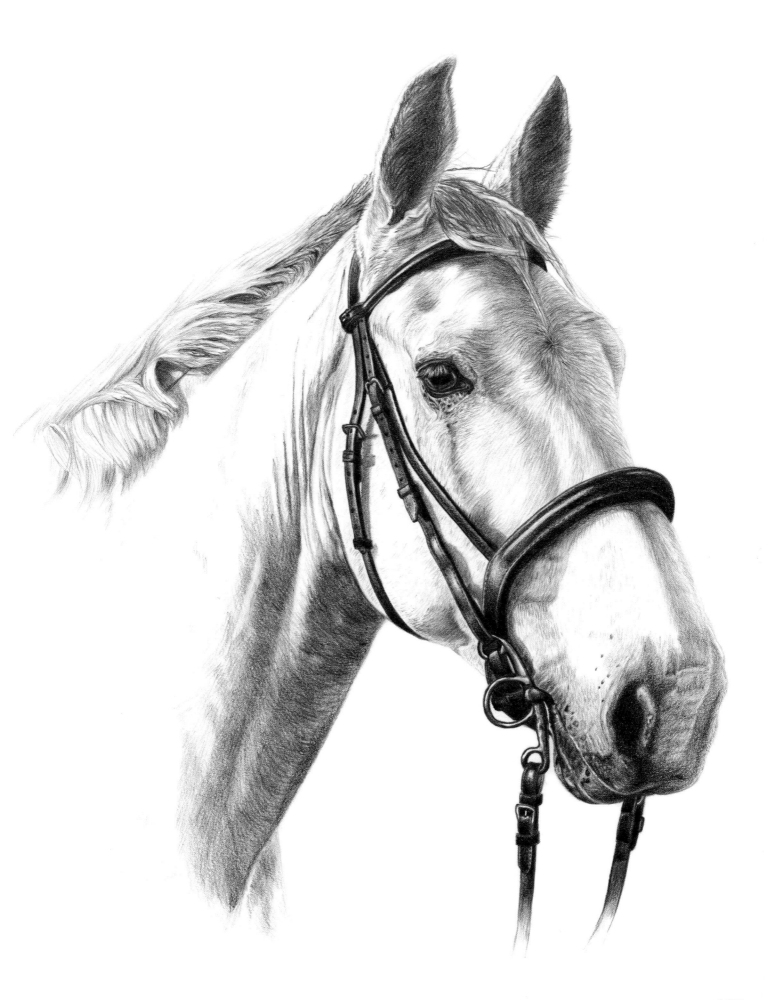

RABBIT

It is highly likely that even someone not keen on rabbits would know what this breed of rabbit is called. There are four different types of lops: English, Holland, French and Mini Lop. The English and the French are larger breeds with the Holland being a dwarf variety. The Mini Lop weighs in at around 2.25kg (5lb), half the weight as the English and French lops.

Lops are a personal favourite of mine, maybe because they look so vulnerable with their floppy ears. As a breed, they are very friendly and affectionate and can become very attached to their owners. They also mix well with other pets in the household – even dogs – but only if introduced properly and supervised at all times!

MATERIALS

Smooth white card, 30 x 42cm (11¾ x 16½in): I use Clarefontaine

2H, 4H, 2B, 3B, 5B and 6B graphite pencils

Pencil sharpener

Putty eraser

Embroidery or darning needle

Spare piece of A4 (8¼ x 11¾in) paper, to rest the ball of your hand on while you work

To download and print out the full-sized photograph of the image below, please visit the web page: www.lucyswinburne.co.uk

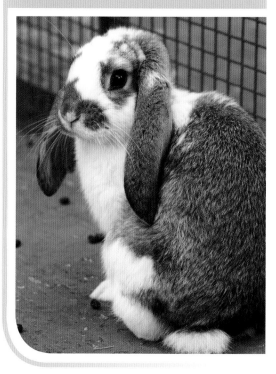

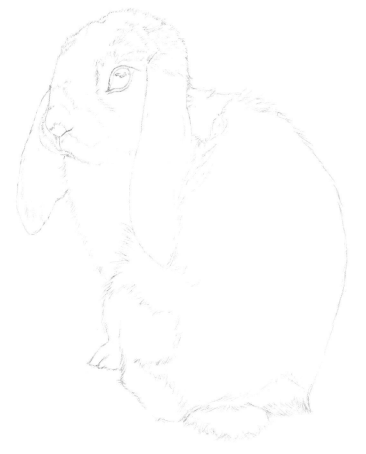

1 **Outline** Draw the outline using your chosen method of grid, tracing or freehand. This outline is drawn in the centre of a 30 x 42cm (11¾ x 16½in) piece of smooth white card with a 2H pencil and the drawing is around 21 x 30cm (8½ x 11¾in) in size. Keep the pressure light when drawing this outline so that mistakes are easily erased and rectified. Have a piece of rough paper close by, ready to rest your hand on as you work, in order to prevent smudging. Although a little of the back of this rabbit is missing from the photograph, I have simply followed the top line of his back and carried it on down and across to his tail.

Indenting Before you start shading, decide if you want to indent any hairs or whiskers. The key places are the white whiskers on the rabbit's cheeks, mouth and chin. Do this slowly and with precision as you can not undo these marks. Make sure your embroidery or darning needle is slim enough for the whiskers by practising on a spare piece of card. Use a 5B pencil to shade over them (crossways) to highlight the indentations you have made.

2 Once your outline is ready and with the indented whiskers in place, select a fairly sharp 4H pencil and add all the highlighted fur within the dark markings on the rabbit's face, ears and back. Begin at the top of the rabbit and work down. Next, use a 2H pencil to add some light shadows within the white fur under the chin, chest and on the rabbit's thigh and tail.

TIP

When you reach the whiskers on the face, be careful with the 4H as it may slip into the indentations, filling them up and spoiling them.

3 **Eye** The eye will establish the darkest tone for the portrait (see inset). Use the 2H pencil to shade in the iris, gently working around the highlights at the top of the eye. There is no pupil to be seen as the eye is too dark, but the eye must still be darkest in the centre, with a slightly lighter section at the bottom where the light is entering the eye. After a couple of light layers of 2H, including shading the outer eyelid, sharpen a 3B and darken the same areas further, still working around the highlights in the iris. Again, after a couple of layers, use a 6B to darken it further. Lift off some of the graphite pencil with a putty eraser to give more emphasis to the light at the bottom of the iris, if required. Shape the highlights, then use the 6B to darken the outer edge of the eye and corner of the eye too.
Fur Now use a fairly sharp 3B to begin to add the dark hairs around the whole eye. Use the 2H to darken some hairs within the white areas and then darken the dark patches of fur more using a sharp 5B pencil. Select a 3B pencil and darken the fur all over the rabbit starting again at the head and working down. Continue to work around the rabbit keeping a careful eye on the fur direction by studying the reference picture as you go. Use the flat edge of the 3B tip to add more shadows within the white fur on the head, back and chest, and not forgetting the thigh, feet and tail. Go back over the rabbit again from head to toe with the 3B, sharper this time and with a slightly firmer touch throughout. When you feel the pencil starting to skate a bit and darkening no further, stop immediately. You are now ready to use a 5B.

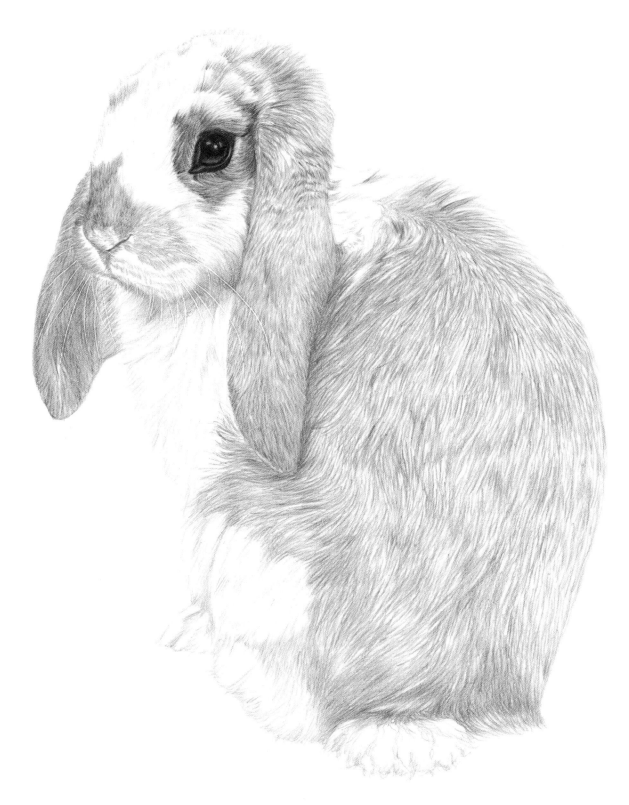

4 Sharpen a 5B pencil and, starting with the head as before, work down building up the dark patches in the rabbit's fur. Continue to work down the face, emphasizing the nose and the roots of the whiskers on his cheeks. Build up the shadow area under the rabbit's right ear and watch the whiskers begin to stand out more and more. Go back over the other ear too, keeping the pencil point sharp. Work steadily down the rabbit's back and towards his bottom and tail. Now you may need to repeat this complete step again if your rabbit is not as dark as the above, but it really depends on how much pressure you used the first time with the 5B.

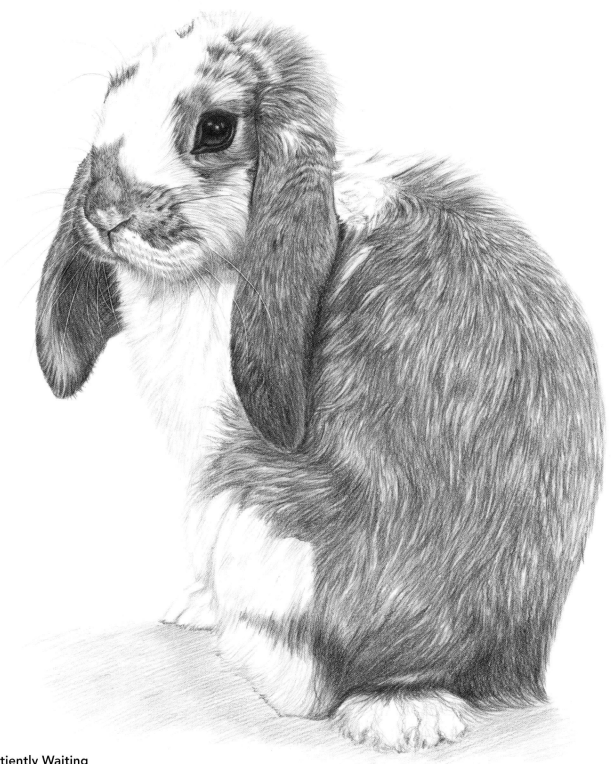

Patiently Waiting
21 x 30cm (8¼ x 11¾in)
Graphite pencil on smooth white card.

At the final stage, deepen the shadows in the white fur using the 2B pencil, not forgetting the foot and tail as before. Use the 2H to add tips to the indented whiskers you added to his cheeks that have no ends to them, flicking them out into the background softly. For the dark whiskers on the rabbit use a sharp 3B pencil.

To create the shadow under the rabbit, start with a light layer of 4H, followed by 2H and then finally darken with 3B. Your rabbit is complete!

131

BEARDED DRAGON

Bearded dragons are native to Australia, where they live in rocky areas. They are great climbers and have quite flat bodies with almost triangular heads, and lots of raised points or horns along the side of their heads and bodies.

When they are upset they can blow out a flap of skin under their beard as a warning, and can also darken the colour of this area to almost black. However, they are generally a very laid-back species which makes them easy to approach in the wild. It is because of this docile personality that they are a popular pet, as children can handle them very easily. In captivity they can grow as long as 61cm (24in) when reared correctly and have a very fast growth rate of around 1cm (½in) a month.

MATERIALS

Smooth white card, 30 x 42cm (11¾ x 16½in): I use Clarefontaine
2H, 3B and 5B graphite pencils
Putty eraser
Pencil sharpener
Spare piece of A4 (8¼ x 11¾in) paper, to rest the ball of your hand on while you work

To download and print out the full-sized photograph of the image below, please visit the web page: www.lucyswinburne.co.uk

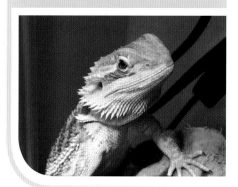

1 Outline Draw the outline with a 2H pencil, using your chosen method of grid, tracing or freehand. This drawing is around 30 x 21cm (11¾ x 8½in) in size, in the centre of a 30 x 42cm (11¾ x 16½in) piece of smooth white card. Do not forget to have a piece of rough paper ready to rest your hand on as you work to prevent smudging. Use a 2H pencil to complete the outline and detail. Unlike other subjects in this book, drawing the outline of the bearded dragon will take time and patience: you need to draw him completely at this stage, scales, horns and all! Spend some time simply studying the reference photograph before you start. This will help you totally understand all the shapes that make up his skin and how to create them. These shapes change from pointed horns to cone shapes and then again to diamond-shaped scales. As you complete the basic outline you will need to copy how the shapes change and follow the shape of his body at the same time.

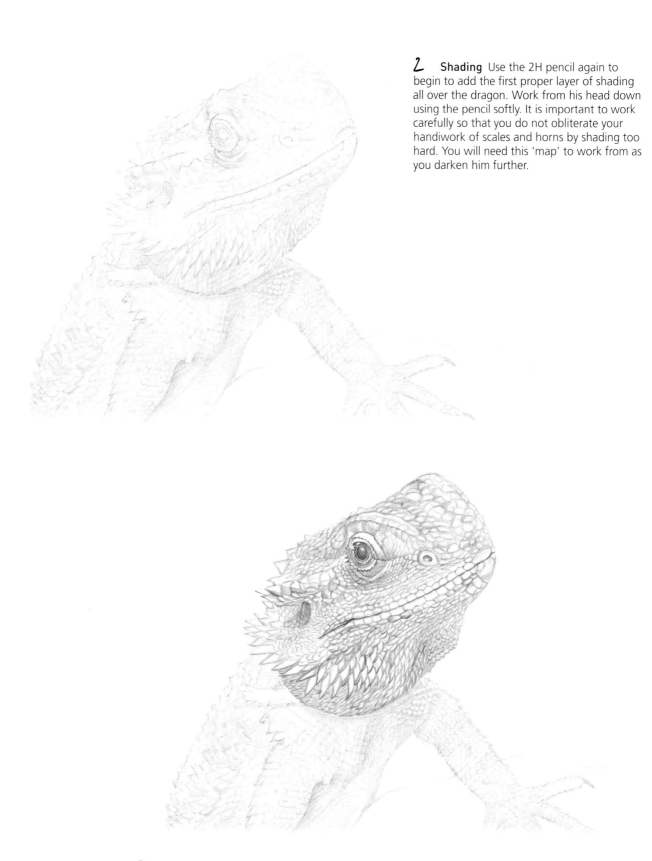

2 **Shading** Use the 2H pencil again to begin to add the first proper layer of shading all over the dragon. Work from his head down using the pencil softly. It is important to work carefully so that you do not obliterate your handiwork of scales and horns by shading too hard. You will need this 'map' to work from as you darken him further.

3 **Head** Use a sharp 3B pencil to darken the shading further on the head. As you work, update the outlines of the scales/horns. Take this first stage slowly as it can be confusing and you can easily get lost. Darken the line of his mouth while the pencil is still sharp, as you can use this area to help gauge where you are if you lose your way. When you get down to the rock on which he is resting you will need some reference to work from. This part will be completed later.

4 **Scales** Once you have been all over him completely with one layer of the 3B, you can begin to use the same pencil to add some of the darker sections of horns on his back. Ensure the pencil is sharp as you work. Use this pencil also to make the cone shapes on his sides stand out more with some undershading and darker outlining. The top of his head between his eyes is very snakelike but the texture is similar to that of smooth pebbles.

Rock To complete the rock simply find some reference – copy a rock from life or find a photograph to help you with the texture. Next, use the 2H to add this texture to the rock he is leaning on. Keep this light for now. When you have completed this, your picture should resemble the image below.

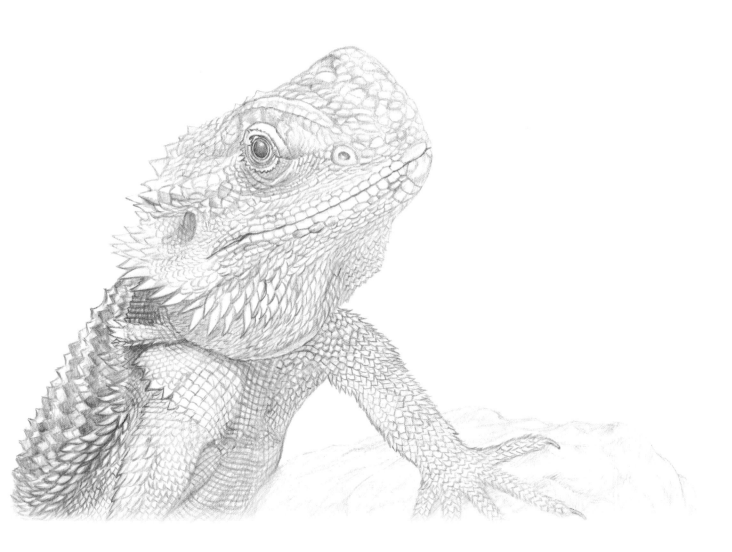

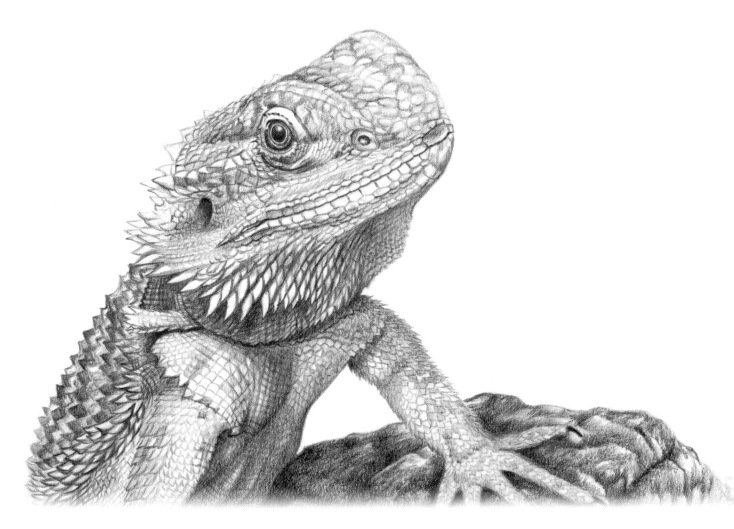

Brian's Beardie
30 x 21cm (11¾ x 8½in)
Graphite pencil on smooth white card.

At the final stage, use a sharp 3B to add some shadows in all of the areas required, this being on his belly, under his beard and chin, under his arms and any other dark areas including his nostril and ear (the hole on the side of his head). Darken his eye and the surrounding area too. As before, try not to obliterate too much of the pattern of scales and ridges you have previously created while you are shading. You can use the putty eraser to lift out sections where you may have shaded too much. Still using the 3B, darken the rock further, creating the darkest section where he is casting a shadow onto the rock itself.

Finally, sharpen a 5B pencil and use it to add even more depth all over the dragon and rock until they resemble the above picture. Congratulations on having the patience to reach the end!

DRAWING ANIMALS IN MOTION

It might seem tricky trying to capture an animal in the process of moving; however, when you really study an animal in flight, there are lots of things happening to tell the viewer exactly what is going on. For instance, the background may be blurred and out of focus if the animal is moving fast, and there could be dust or water spraying up around them, depending on their location. Observe their limbs carefully – they will look very different to those of an animal at rest. A running or moving animal will likely have knees or elbows bent or their legs could even be at straight angles behind them, having just propelled them forwards. Other things to help suggest movement are tails or manes flying in the breeze, ears flapping from a jump and even highly concentrated facial expressions. All you need to do

Galloping Foal
21 x 29.75cm (8¼ x 11¾in)
Graphite pencil on smooth white card

This lovely little foal is obviously revelling in being outdoors in the sun, kicking up his legs and having a run! One of the obvious signs here is the way the head is held at quite a stiff angle, in a forwards position. Other signs are his tail flying up in the wind, due to the movement; his forelegs curled up under him, ready for the next running step; and his back hooves on the ground, pushing him forwards. You don't need dust and a blurred background to show he is covering some ground!

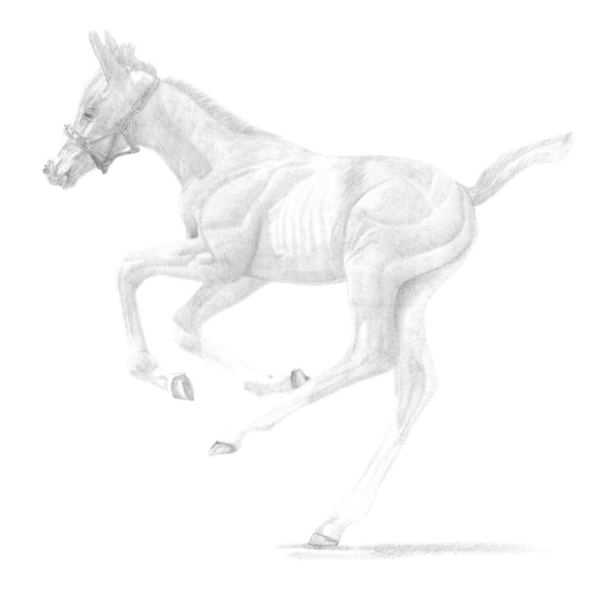

is capture the key body language in the animal that articulates it is in motion, and you will clearly demonstrate to your viewer exactly what is happening.

Don't be afraid to use your own pets as guinea pigs first (excuse the pun!) and practise photographing them moving. Catching your cat mid-stalk or your dog jumping for a frisbee, for example, would be great opportunities to start practising drawing movement. Even capturing your hamster mid-spin in his wheel, or your rabbit mid-hop, are all good chances to freeze-frame the movement.

I have provided a couple of examples here, to show you exactly what I am referring to.

Jumping Dog
29.75 x 21cm (11¾in x 8¼in)
Graphite pencil on smooth white card

Another good example is this image of a dog mid-jump. Again, there is nothing – not even a shadow – to suggest what is actually happening, and yet his body language is telling the story. However, to do this effectively, the animal has to be in the middle of jumping, with all four legs stretched out so it is suggested that none of his feet are touching the floor. There has been considerable effort to help propel him forwards, and this can be established by how far back his legs are behind his body. His forelegs are also stretched out to help him reach his goal.

ASIAN ELEPHANT IN MOTION

With this step by step you are going to capture the movement of an Asian Elephant calf mid-run. You don't always have to show movement with dust being kicked up, or a blurred background – again, the subject's body language and limb positions should convey this. On this little calf, the obvious signs of motion are the arched tail lifted into the air; the back leg splayed out behind the other legs, from recently propelling him forwards; and the front left leg lifted and bent at the knee, ready for the next part of his journey. I hope you enjoy creating him with me.

MATERIALS

Smooth white card, A4 (8¼ x 11¾in) in size: I use Clarefontaine

2H, 2B, 3B and 4B graphite pencils

Pencil sharpener

Putty eraser

Spare piece of A4 (8¼ x 11¾in) paper, to rest the ball of your hand on while you work

To download and print out the full-sized photograph of the image above, please visit the web page: www.lucyswinburne.co.uk

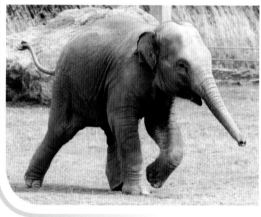

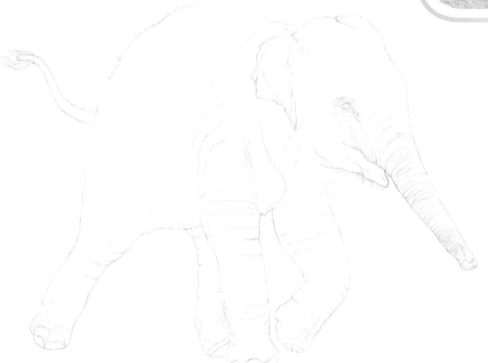

1 Outline Draw the basic outline using your chosen method of grid, tracing or freehand, using a 2H pencil. Keep the pressure very light with the pencil to prevent making indentations in the card; the outline just needs to be dark enough for you to see. If it is quite dark when you have finished, use your putty eraser to lift some of the pencil off.

2 Building details Start shading in the front of the calf by gently cross-hatching with a 2H pencil. If the pencil has been recently sharpened, blunt the tip slightly by rubbing it on a spare piece of paper, turning it round as you do so that there is even wear across the tip – the 2H can leave scratchy pencil marks on the surface of the card if it is too sharp, which are hard to remove. Use your spare piece of A4 (8¼ x 11¾in) paper to rest your hand on as you work, to protect the rest of the card from getting marked. Begin with his head, softly adding lots of lines in the directions of the shapes you can see on the reference photograph to suggest the contours you distinguish. Remember to copy carefully the way the lines accentuate his anatomy, going up, down and around curves on his skull and trunk. Don't forget to add in his eye at this point: it will give him a bit more character. When the pencil is sufficiently soft and worn down a little more, you can start to add some shading at the base of his ear, around his mouth and eye, and in the indent at the top of his head, to make him more three-dimensional.

3 Adding more details Continue using the 2H pencil to build up the skin all over the elephant. You can see where I have started to build up the area at the top of his back with light lines and fine hairs – adding more lines that go in different directions (following your reference photo) will build up the depth slowly. Remember to keep the lines curved as you work on the top of his back.

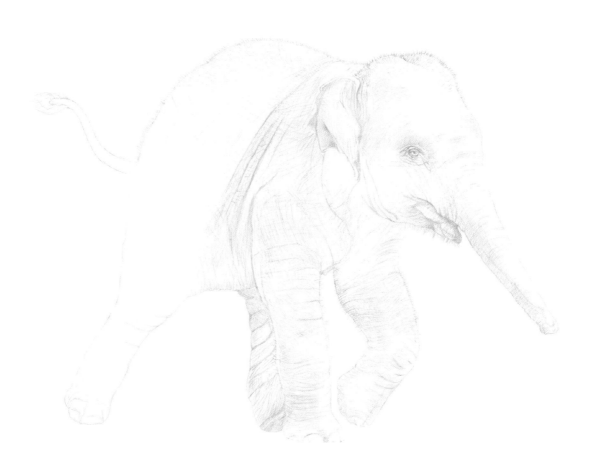

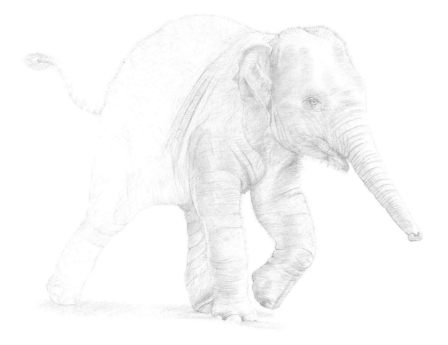

4 **Tone** When you have gone over the whole elephant with a soft layer of pencil lines, with a little shading applied here and there in between, you can go back over the whole elephant once again with a firmer hand. Still keep the 2H pencil unsharpened, turning the pencil tip to use a sharper edge when required. You should have a very soft edge at the point, and you can use this to your advantage for shading.

Shadows Add in the shadow under the elephant, suggesting the ground he is running on, using your pencil at quite a low angle. You need to keep this angle consistent throughout, or your shadow will look as if it is standing up.

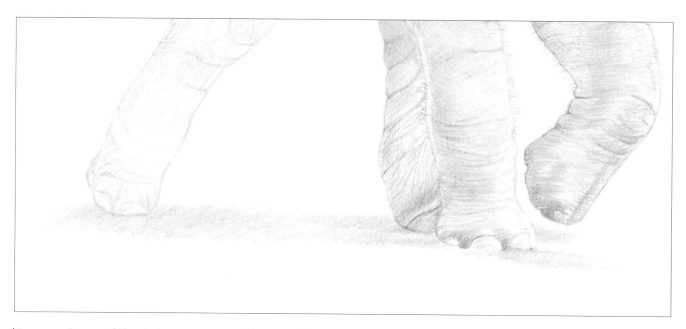

'Here is a close up of the shadow, so you can see the angle of the shading. It's a good idea to practise the angle you need on a spare piece of paper first, to see if you can hold your pencil this way, before you do this on the actual drawing.'

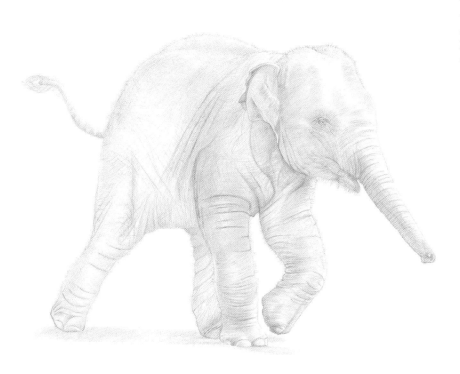

5 **Adding further tones** Continue to work over and shade in the whole of the elephant with the soft tip of the 2H pencil, accentuating the deeper lines carefully with the sharper part of the pencil tip.

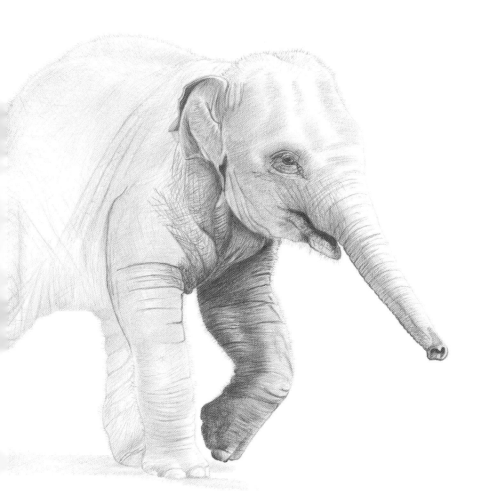

6 **Adding texture and details** Sharpen the 2B pencil and begin to darken the elephant's skin and wrinkles, starting from the top of the head and working down. Fill in the pupil in the eye to darken it, based on your reference picture, and shade in the iris too. Make sure you keep resting your hand on the paper as you work, to avoid smudging the drawing.

TIP

At this stage in the shading, it's good to decide early on where the darkest darks will be applied in the drawing. From this, you can gauge how dark the other darks on the subject should be drawn. For instance, the shadow inside the elephants mouth is as dark as the pupil, as is the inside of the end of the trunk.

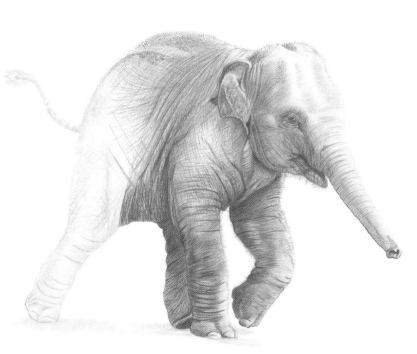

7 **Adding depth** Continue to build up depth in the calf's body with the 2B pencil. It's really important that you keep referring back to the original photograph as you are working, to ensure you are shading in the elephant's body correctly. As you are adding all the lines and wrinkles, you also have to take into account his body shape: take care that the lines are not too straight and follow the curves of his body. If you don't, he will look more flat than three-dimensional. Don't worry about making the texture exactly the same as those in the reference picture; it gets incredibly confusing trying to follow them line for line.

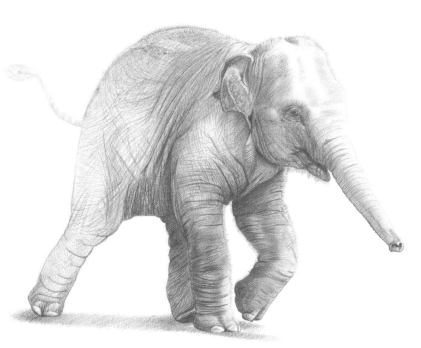

8 **Continuing to add depth** Sharpen your 2B pencil every now and then to keep the heavier wrinkles crisp and sharp, so they stand out against the overall shading. Don't forget to keep resting your hand on the rough paper to prevent smudging, and clean up your background with the putty eraser if there are any pencil smudges you can see. He's nearly complete now – not long to go!

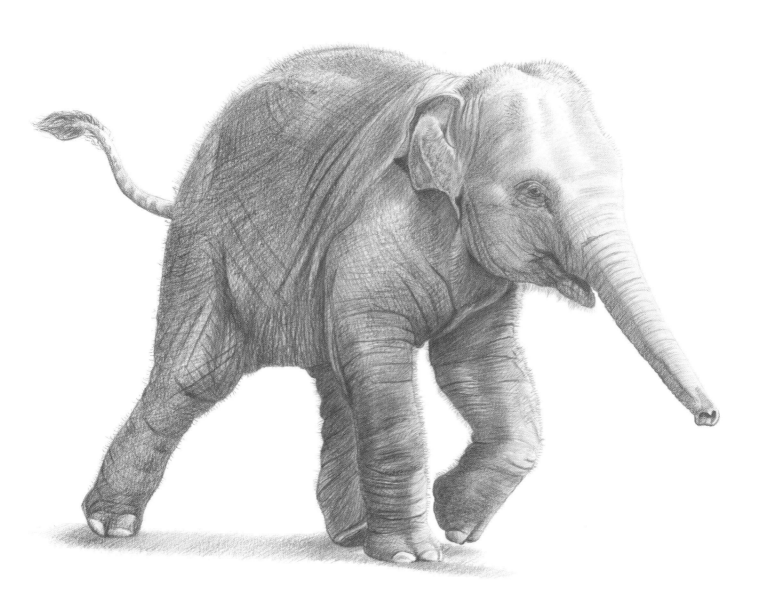

Finished Asian Elephant
30 x 21cm (11¾ x 8¼in)
Graphite pencil on smooth white card.

Having gone back over the elephant with the 2B pencil – not forgetting his tail – sit back and have a look at any areas you feel need darkening further. Use this image above as a guide, if you wish. Once you have done this, sharpen the 2B and go back over any prominent wrinkles to make them stand out. Sharpen the pencil again and go back over the little bristly hairs on the elephant's body, including his legs and back, and his head especially. Use your putty eraser to lift off any pencil spots or smudges in the background. Your running elephant is now complete.

INDEX